EXPLORE

HARVARD

EXPLORE

HARVARD

THE YARD AND BEYOND

Edited by

Harvard Public Affairs & Communications

INTRODUCTION BY SEAMUS HEANEY

Harvard University Press
Cambridge, Massachusetts
London, England
2011

Excerpt from "Little Gidding," Part V in *Four Quartets,* copyright © 1942 by T. S. Eliot and renewed 1970 by Esme Valerie Eliot, reprinted by permission of Houghton Mifflin Harcourt Publishing Company; and Faber and Faber Ltd. *(Collected Poems, 1909–1962).*

Excerpt from "The Course of a Particular," from *The Palm at the End of the Mind,* by Wallace Stevens, ed. Holly Stevens, copyright © 1967, 1969, 1971 by Holly Stevens, reprinted by permission of Alfred A. Knopf, a division of Random House, Inc. Also used by permission of Faber and Faber Ltd. *(Collected Poems).*

Excerpt from "Mind," from *Hybrids of Plants and of Ghosts,* by Jorie Graham, copyright © 1980 by Princeton University Press.

Excerpt from "A Place: Fragments," from *Selected Poems, 1965–1975,* by Margaret Atwood, copyright © 1976 by Margaret Atwood, reprinted by permission of Houghton Mifflin Harcourt Publishing Company; Curtis Brown Group Ltd., London, on behalf of Margaret Atwood; and Oxford University Press (copyright © 1976 by Oxford University Press Canada).

Excerpt from "The School Among the Ruins," from *The School Among the Ruins: Poems, 2000–2004,* by Adrienne Rich, copyright © 2004 by Adrienne Rich, reprinted by permission of the author and W. W. Norton & Company, Inc.

Excerpt from "my mind is," copyright © 1925, 1953, 1991 by the Trustees for the E. E. Cummings Trust. Copyright © 1976 by George James Firmage, from *Complete Poems: 1904–1962,* by E. E. Cummings, ed. George J. Firmage. Reprinted by permission of Liveright Publishing Corporation.

Excerpt from "Baseball," from *Endpoint and Other Poems,* by John Updike, copyright © 2009 by the Estate of John Updike, reprinted by permission of Alfred A. Knopf, a division of Random House, Inc.

LIBRARY OF CONGRESS CATALOGING-IN-PUBLICATION DATA

Explore Harvard : the yard and beyond / edited by Harvard Public Affairs and Communications ; introduction by Seamus Heaney.

 p. cm.

 ISBN 978-0-674-06192-7 (alk. paper)

 1. Harvard University—Pictorial works.

 LD2155.E97 2011

 378.744'4—dc23

2011019103

EXPLORE
HARVARD

INTRODUCTION

Begin again where frosts and tests were hard.
Find yourself or founder. Here, imagine
A spirit moves, John Harvard walks the yard,
The books stand open and the gates unbarred.

Villanelle for an Anniversary

AMONG THE SCORES OF VIVID PHOTOGRAPHS in this marvelously comprehensive volume celebrating life at Harvard, there are two in close proximity which signify much that the whole book encompasses. One shows a group of more than thirty landscape design students at work on the front and roof of the Graduate School of Design, spreading soil and earthing plants at different levels. Each student is engaged in his or her own task on his or her own level, but they—and the whole photograph—are united by a concatenation of ladders which compose a kind of landlubber's rigging. Floor by floor each short ladder adds to the single ascending upreach whereby the whole thing becomes an image of aspiration, of individual endeavor gaining momentum and meaning from being part of a shared activity. Constituting, indeed, the idea of a university.

Complementing this decidedly sky-oriented venture is a photograph of students taking part in the Harvard Summer School's Yard Dig—a

down-to-earth spade-and-trowel job, ground being sifted, yielding its secrets sparsely. It is meticulous work, unspectacular but intensely focused, not unlike the workaday attention a student must pay to his or her academic assignments: even if the subject is astrophysics the student's feet must stay firmly on the ground covered in the coursework.

The overall story this book has to tell, however, is one neither of light-headedness on high nor of delving into earth below: it is more about an in-between condition we might call buoyancy. The many pictures of undergraduates at work and at play reveal a student population capable of plotting a course between the high academic tests which all have to pass, whatever their discipline, and those other exercises, athletic and artistic, which invigorate the body and the spirit. Brio and commitment shine off these pictures, whether of students serving on outreach programs in Africa or enjoying themselves nearer home, splashing through muddy puddles in the Yard; whether watching or playing in "the Game" with Yale or dining in splendor in Annenberg Hall.

For fourteen years, between 1982 and 1996, I was the beneficiary of that collective brio and buoyancy: for one term a year I resided in Adams House, which during the 1980s was one of the more flamboyant—and proud of it—houses. I still remember a dramatic production in the dry swimming pool in which the protagonist played a legendary Irish king stark naked. Less arresting but as memorable, for its fervor but also for its length, was a poetry reading in the Junior Common Room by Robert Bly. There was also the Bow and Arrow Press, which did beautiful printing of poems, and those Friday afternoon teas in the master's house, where music and poetry formed a natural part of the civilized proceedings.

One of my own tests at Harvard occurred in the Tercentenary Theatre, or perhaps better say the Yard. Early in 1986, the 350th anniversary of the founding of Harvard College, the university marshal, Richard Hunt, asked me to write a poem to mark the occasion. I was immediately uneasy, not sure I could fulfill the commission, so I put it to Richard that I was neither an American nor a graduate of Harvard and therefore not

the best person for the job. "But," he retorted, "you have been a professor here for four years," and I could see his point. Even so, I was still not sure I could produce the poem to order.

This came back to me when I saw the wonderful close-up, included here, of John Harvard's toecap, its bronze turned to gilt by generations of students who have rubbed it for good luck. It so happened that in the spring of 1986 I too could be found haunting that Harvard statue and also reading the history of the college, learning that John was neither a founder nor a teacher but a benefactor. But when I read that he was the son of a butcher who had moved from Stratford-on-Avon to Southwark and that the original schoolhouse was beside the cattle sheds, I found—because of my own early familiarity with cattle and farmyards—a sense of connection that allowed me to get started on a "Villanelle for an Anniversary."

And from the moment I read the poem to the mighty assembly at that year's Commencement, my sense of relationship with Harvard deepened to the point where I feel immediately at home with this beautiful, bountiful cornucopia of images, seasonal, architectural, social, artistic, athletic images "that yet"—as W. B. Yeats put it—"Fresh images beget."

Seamus Heaney
Dublin, Ireland
March 2011

I

We shall not cease from exploration
And the end of all our exploring
Will be to arrive where we started
And know the place for the first time.

T. S. Eliot, A.B. '09, A.M. '11,
Litt. D. '47, from *Four Quartets*

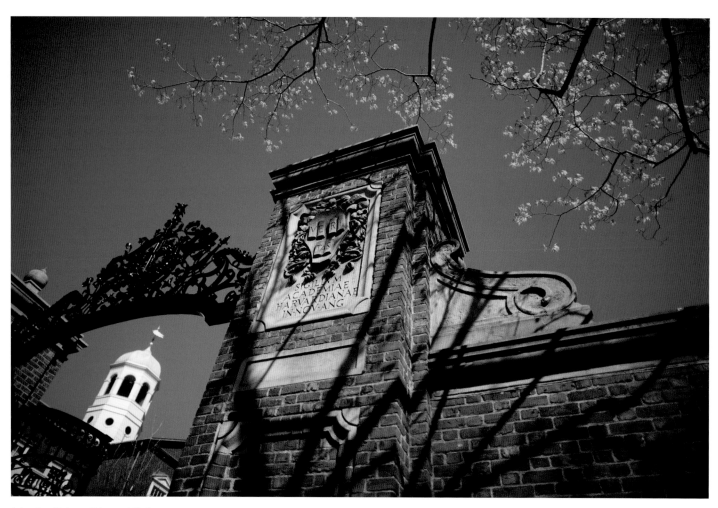

Johnston Gate and Harvard Hall, 2010

PASS THROUGH JOHNSTON GATE on your way to the Yard, salvaged bricks stacked high to form two towers joined by a span of wrought iron embracing a small cross. On your left, an inscription set in stone memorializes the date, 28 October 1636, when the General Court of Massachusetts Bay agreed to give the considerable sum of 400 pounds toward the founding of a college. On your right, the words engraved recall the motivations of the men who established what became Harvard, with a single master and nine students to "advance learning and perpetuate it to posterity."

Much has changed since the time when a successful applicant needed to "speak true Latin in verse and prose" and "decline perfectly the paradigms of nouns and verbs in the Greek tongue." More than eighty ancient and modern languages are taught through the College and the University's twelve graduate and professional schools to some twenty thousand degree candidates who reflect a diversity of faiths, colors, and creeds that would have astounded the original master of the College and his nine young scholars. Today women not only attend classes alongside the men; they teach them, and they hold leadership positions at every level of the institution.

The desire to advance learning has persisted through the centuries. Even today, the young men and women who arrive at this campus set by a slow bend in the Charles River and walk past Massachusetts Hall on their way to a lecture at the Barker Center, a concert at Memorial Hall, or a Science Center lab are motivated by the same spirit of exploration that provided the impulse for the founding of the College.

8

Weeks Footbridge, 2009

Entryway to Robinson Hall, 2009

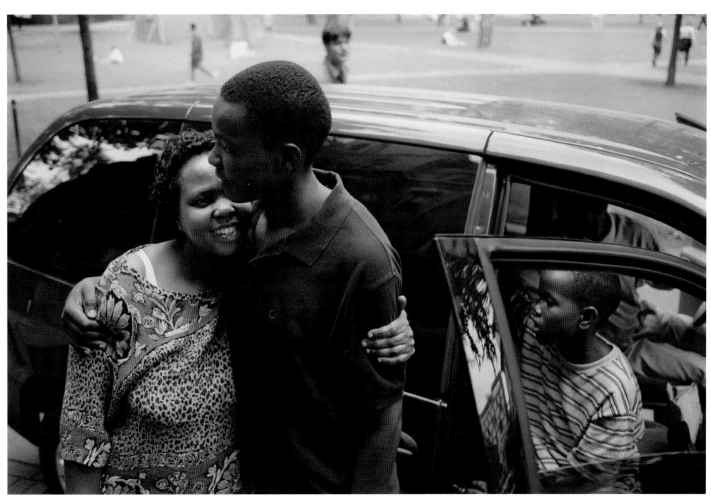

Move-in day in Harvard Yard, 2000

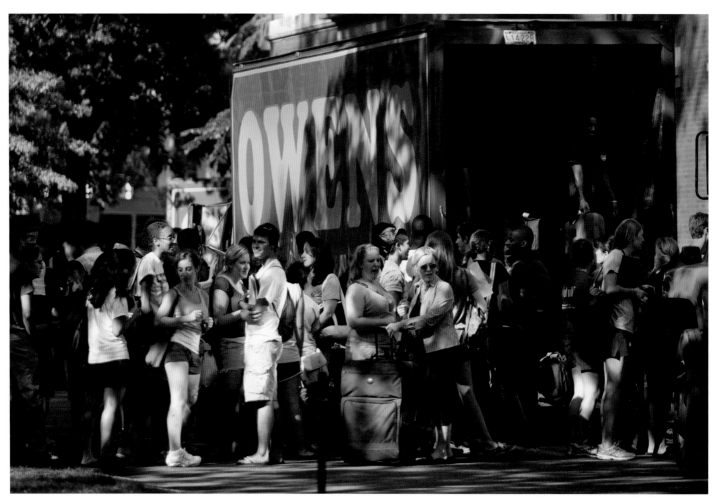

Move-in day in Harvard Yard, 2008

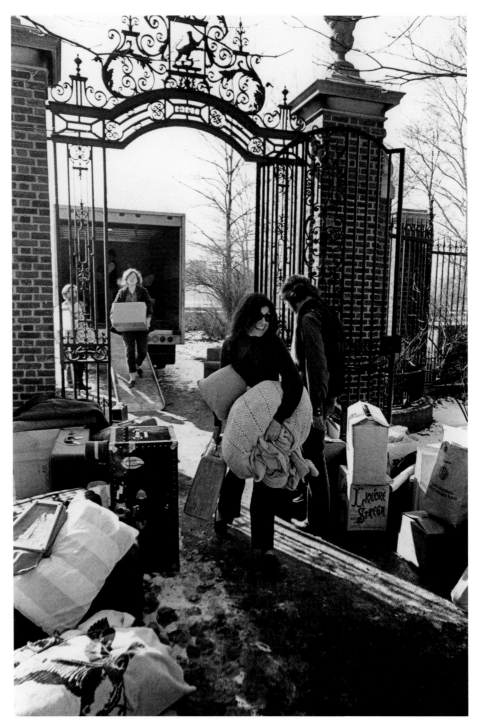

First women move into Winthrop House, 1970

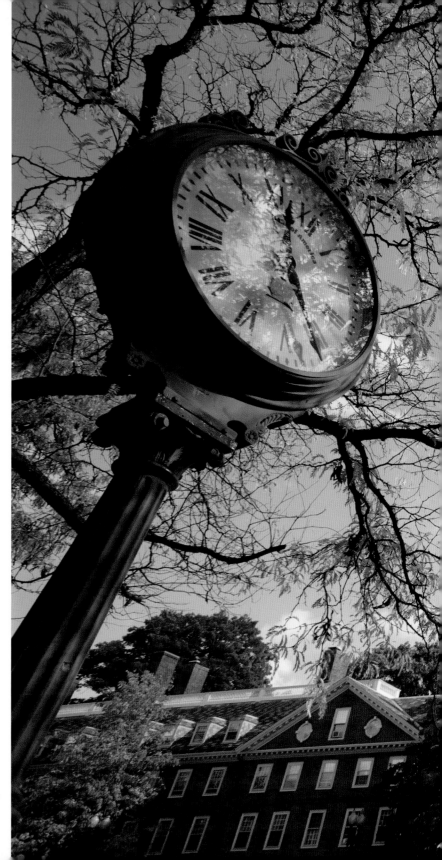

18

Straus Hall and Dudley House, 2009

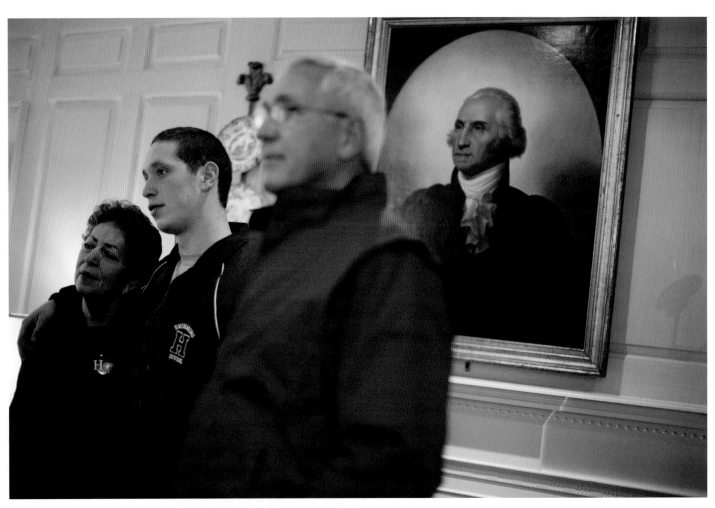

Freshman Parents Weekend tour of Wadsworth House, 2009

16

New arrival in Moors Hall, ca. 1961

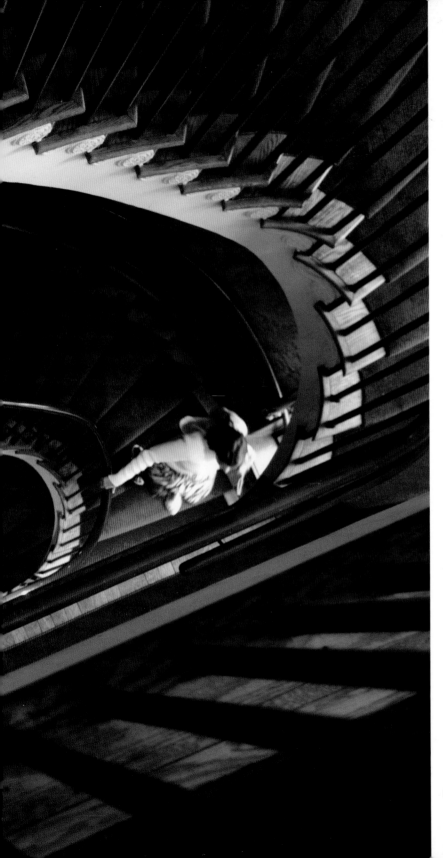

15

Harvard Faculty Club, 2006

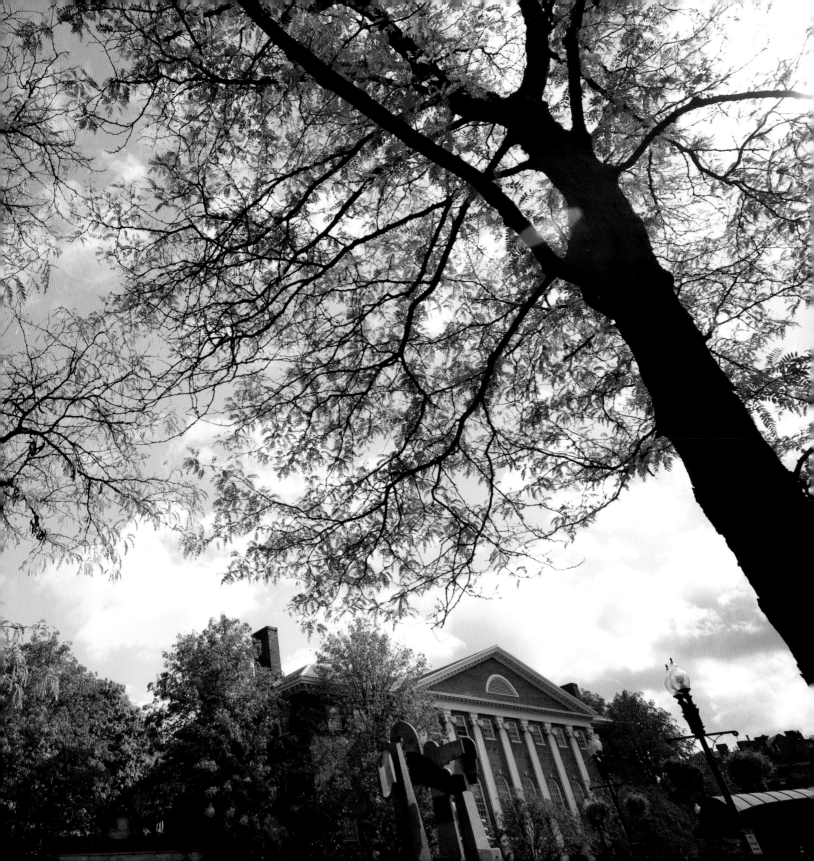

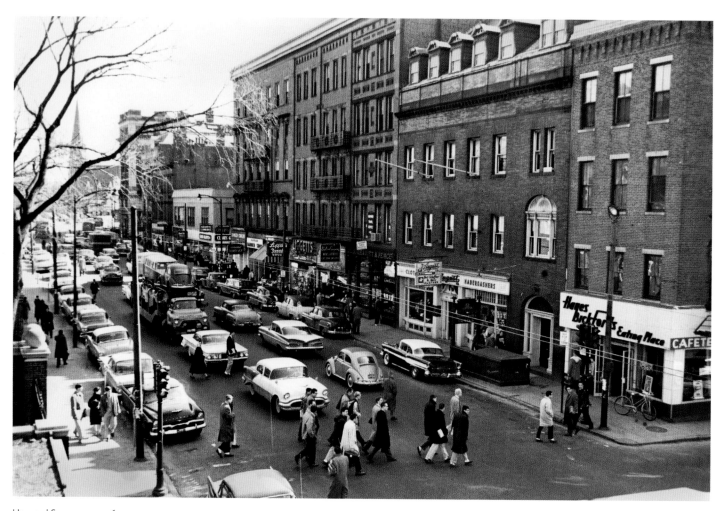

Harvard Square, ca. 1960

20

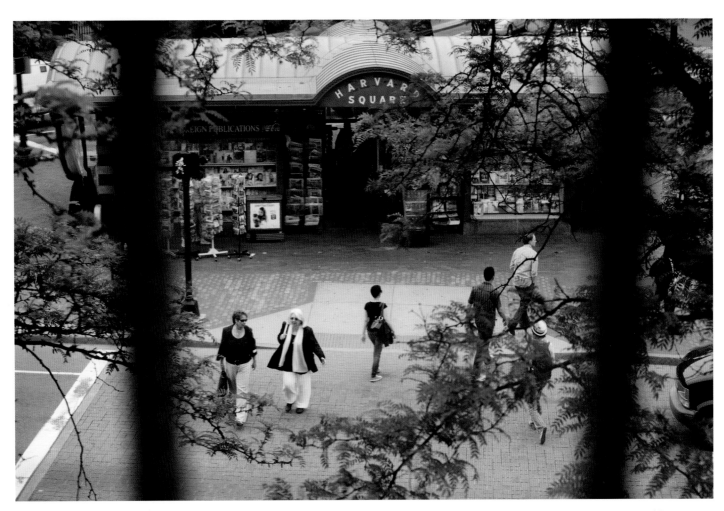

Harvard Square, 2010

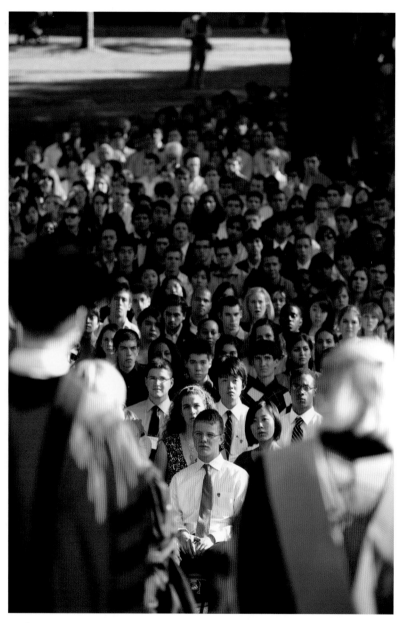

Freshman Convocation in Tercentenary Theatre, 2009

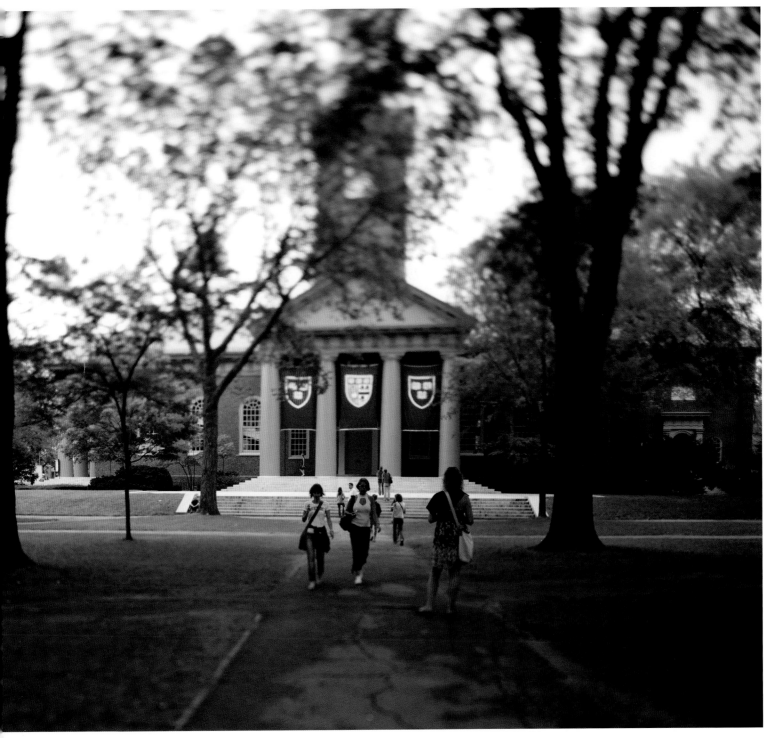

23

Harvard Yard, 2008

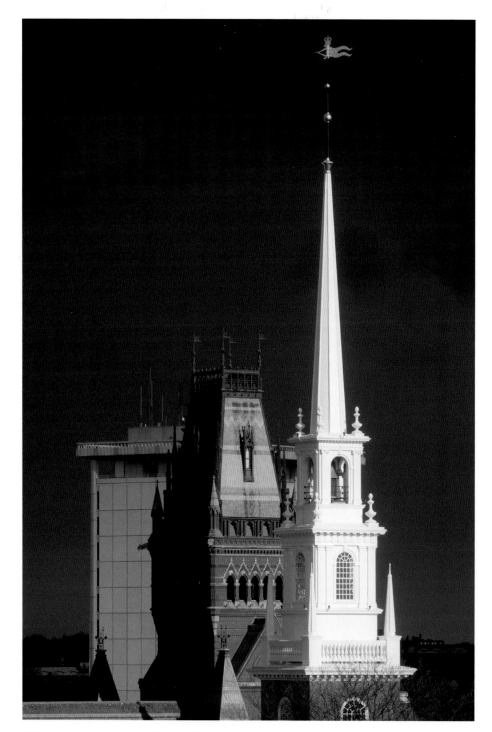

William James Hall, Memorial Hall, and Memorial Church, 2006

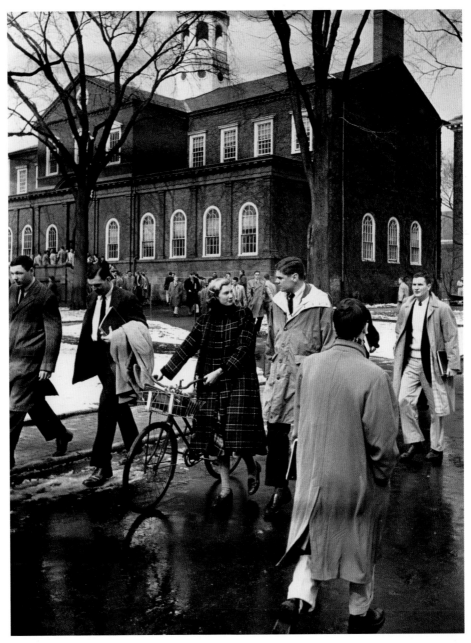

Harvard Yard, 1955

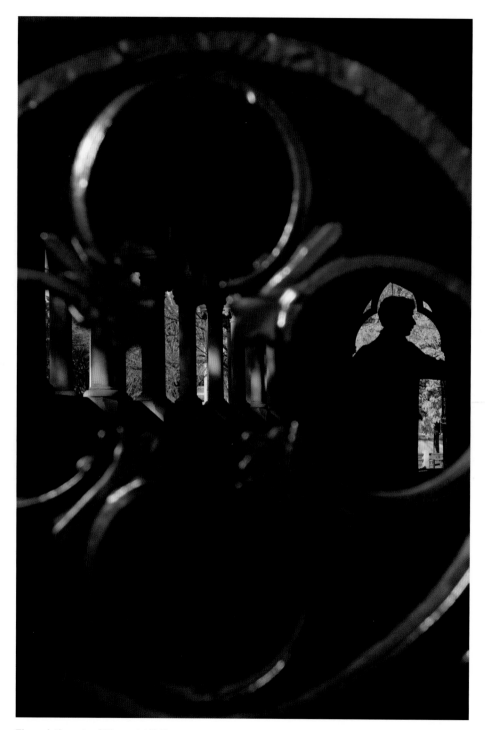

Through the gate of Memorial Hall, 2009

Houghton Library, 2009

I I

Today the leaves cry, hanging on branches swept by wind,
Yet the nothingness of winter becomes a little less.
It is still full of icy shades and shapen snow.

<div style="text-align: right">

Wallace Stevens, attended Harvard 1897–1900,
Litt. D. '51, from "The Course of a Particular"

</div>

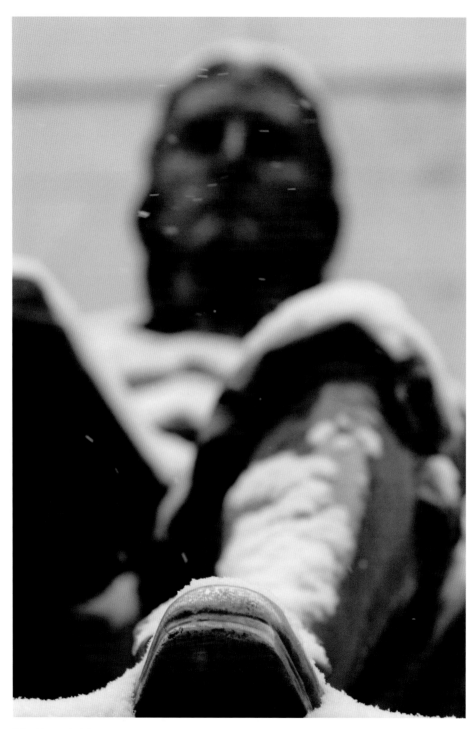

John Harvard statue, 2003

Sunlight glints off spires white and domes of gold and blue and crimson. Wind scatters brown leaves around the crossing paths tread by generations of students and scholars. How many lost in thought missed the grand arches of Memorial Hall or walked unawares past the obelisk finials of the Weeks Footbridge with the soundless river running below? How many were comforted when winter's blanket covered the Yard? Winter, spring, summer, fall—the stark colors of the New England seasons are as much a part of the Harvard landscape as the Colonial Revival buildings that surround the Yard, or the thousands of visitors who come year after year to rub the toe of John Harvard's boot. Frames of steel and glass shaped into dozens of styles now stand among the buildings of water-struck brick familiar to any who have walked across campus, creating an architectural setting as varied as the vast collections of the Harvard Library. What happens in the spaces between where we are coming from and where we are going? In the details of the familiar, we can find a greater sense of place. Inspiration waits in a shadow cast across the ground.

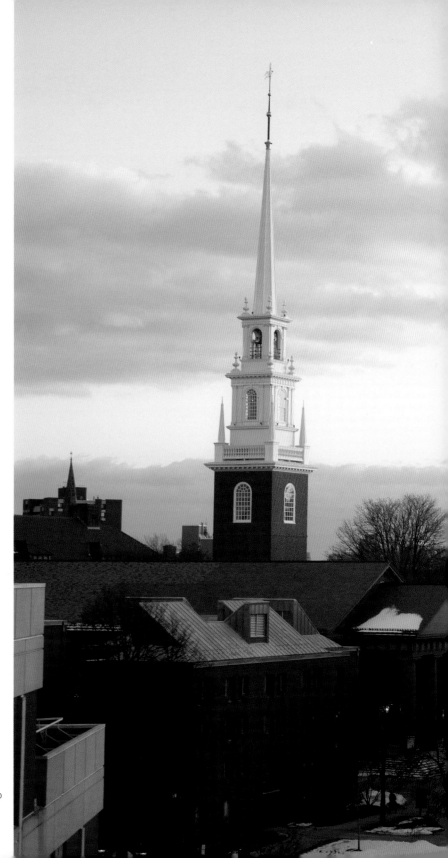

Harvard Yard, 2010

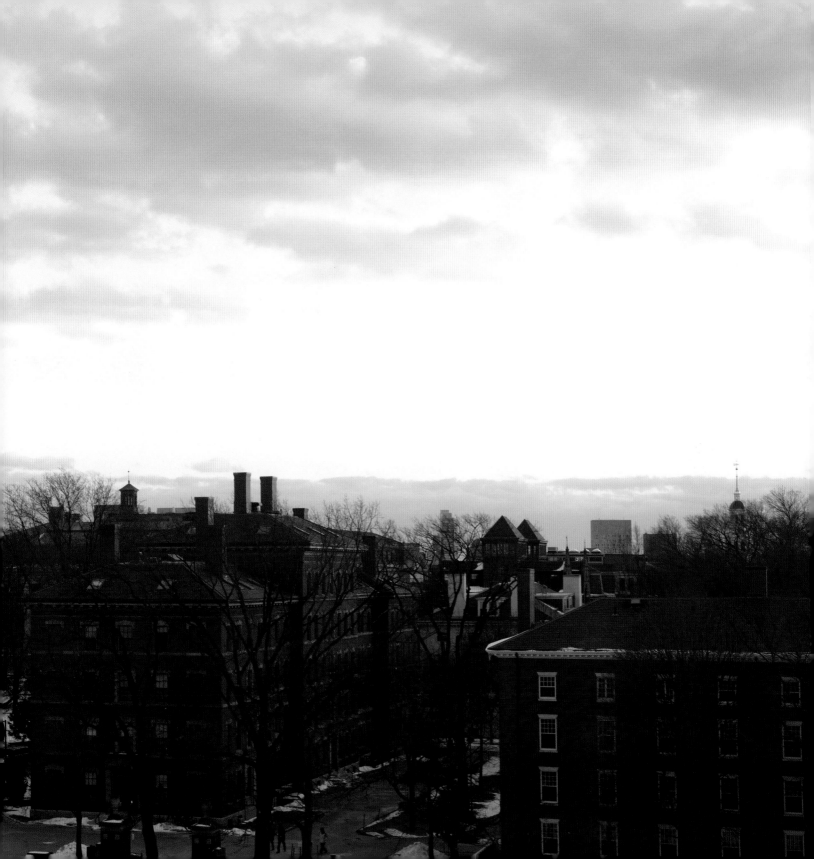

William James Hall, 2010

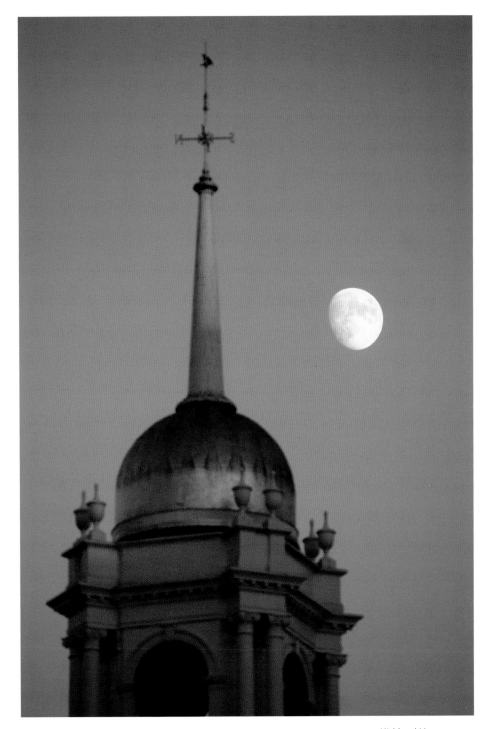

Kirkland House, 2005

Painterly perspective at the Carpenter Center, 2009

Passage through Harvard Divinity School, 2003

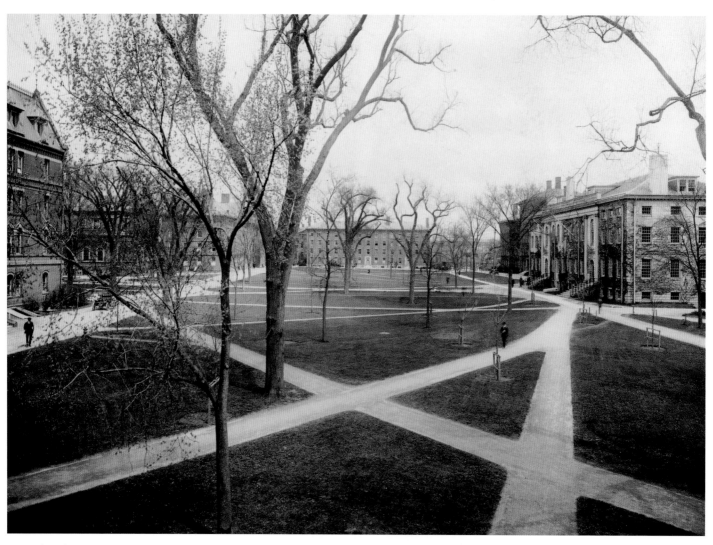

Harvard Yard, 1915

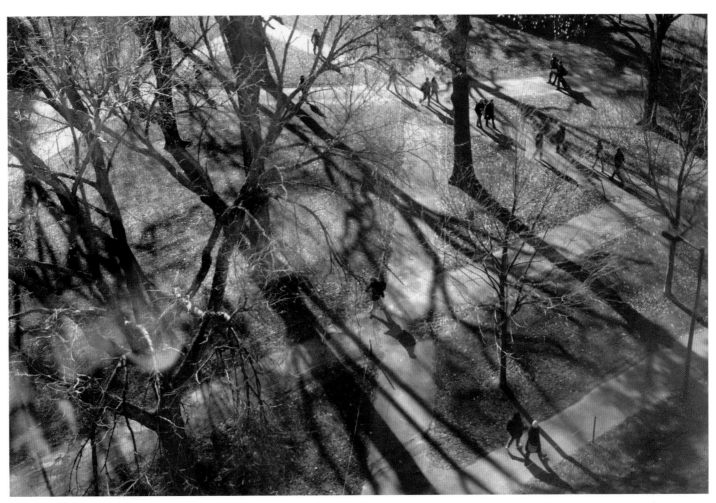

Kaleidoscopic paths across Harvard Yard, 2005

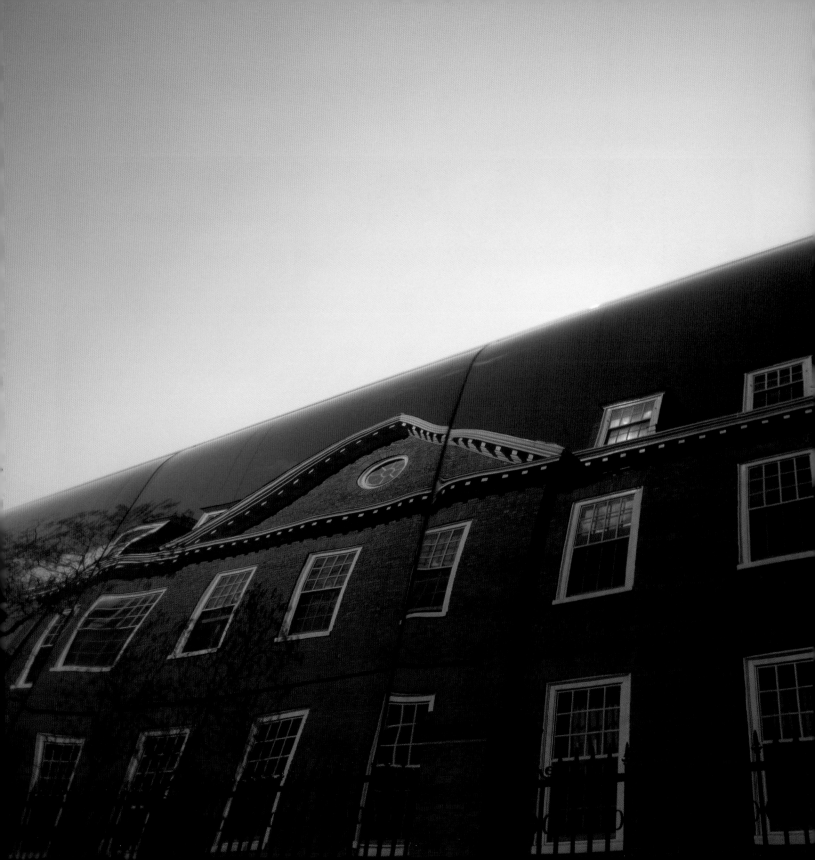

41

Reflection of Wigglesworth House, 2010

Threaded tree limbs shroud Widener Library, 2010

42

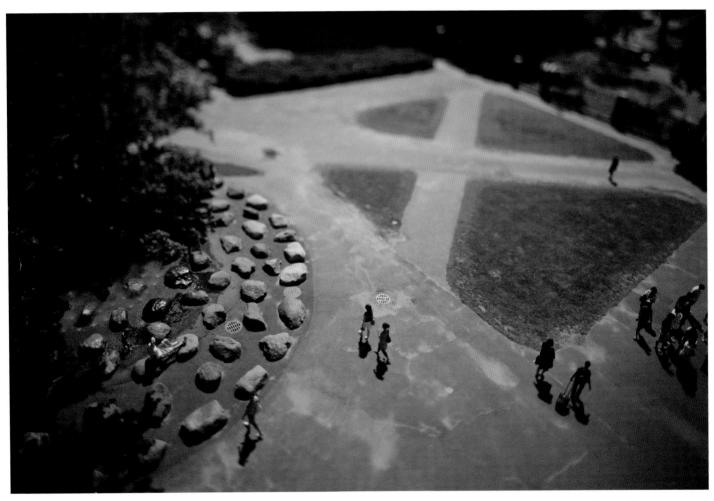

Science Center lawn, 2008

43

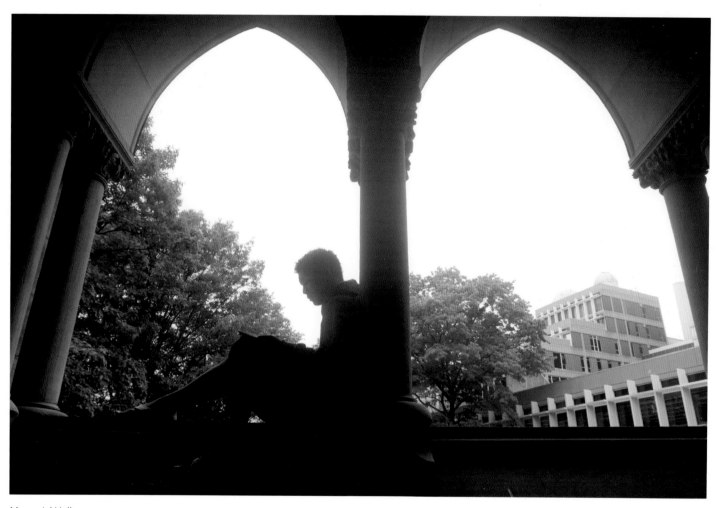

Memorial Hall, 2009

44

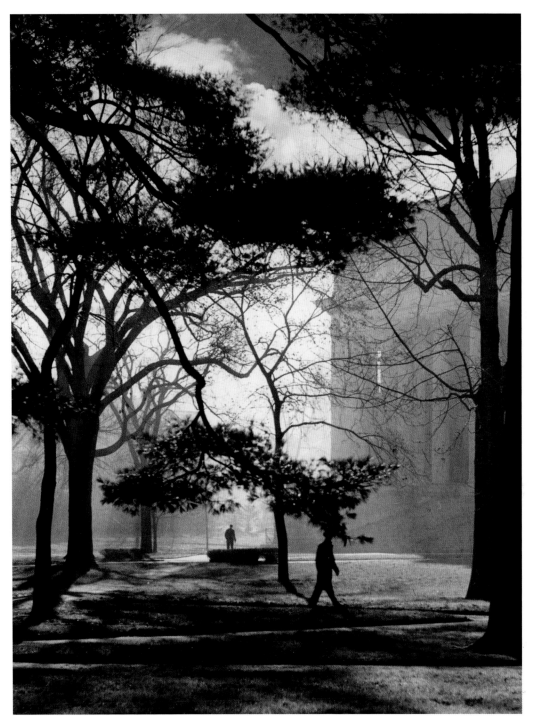

Harvard Yard, ca. 1940

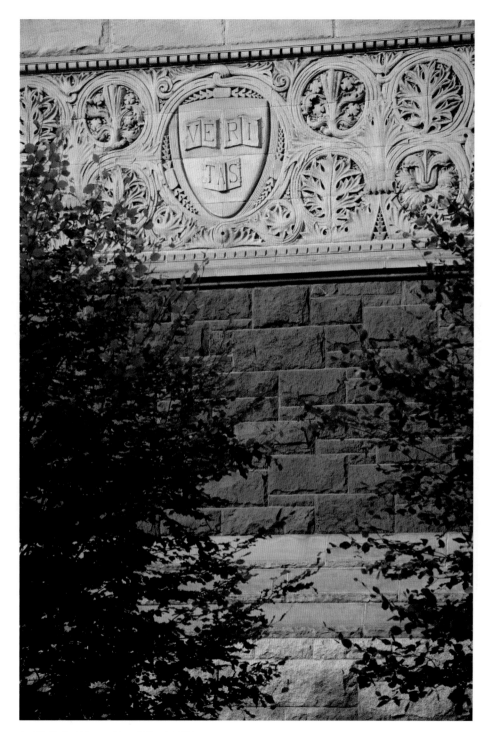

Austin Hall at Harvard Law School, 2010

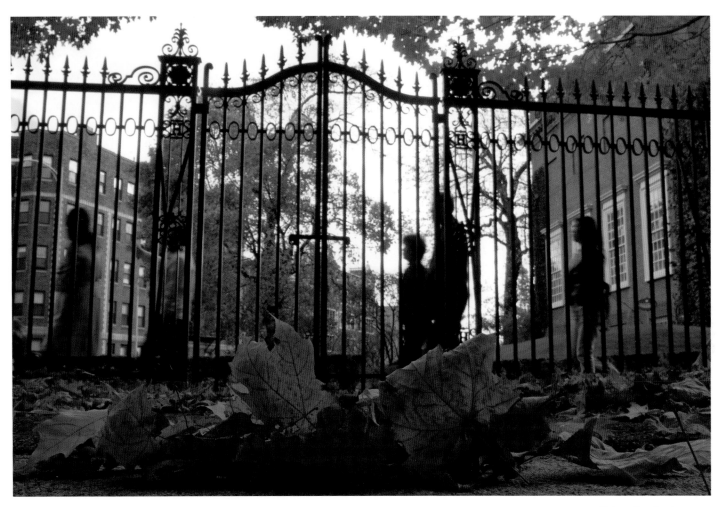

Quincy Street gates, 2005

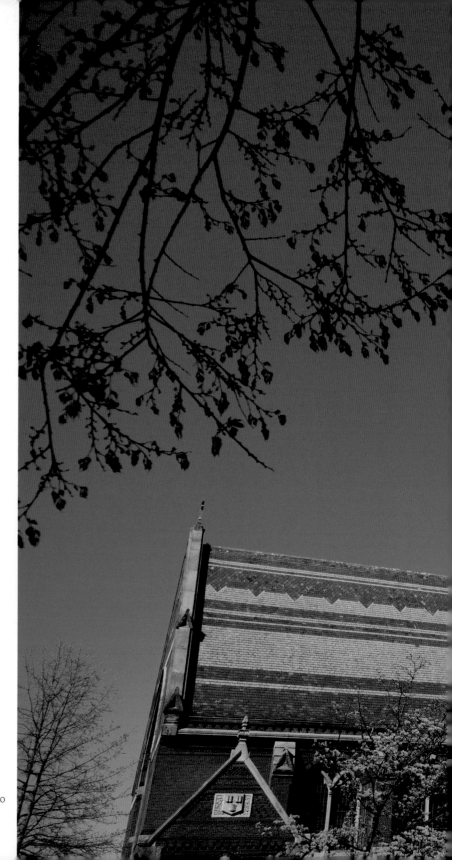

Memorial Hall, 2010

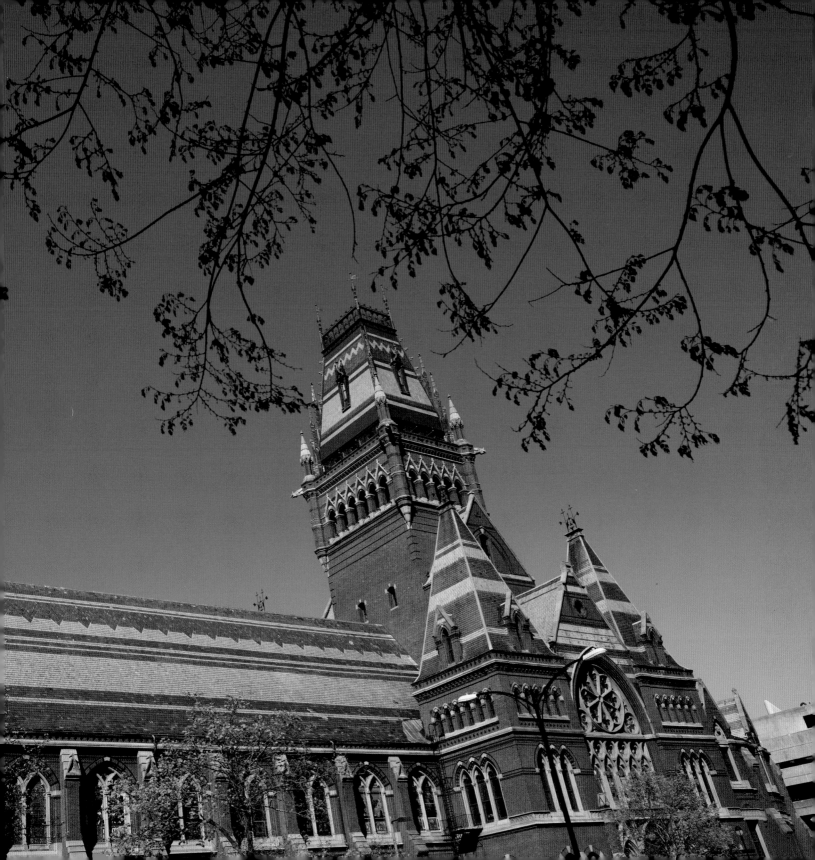

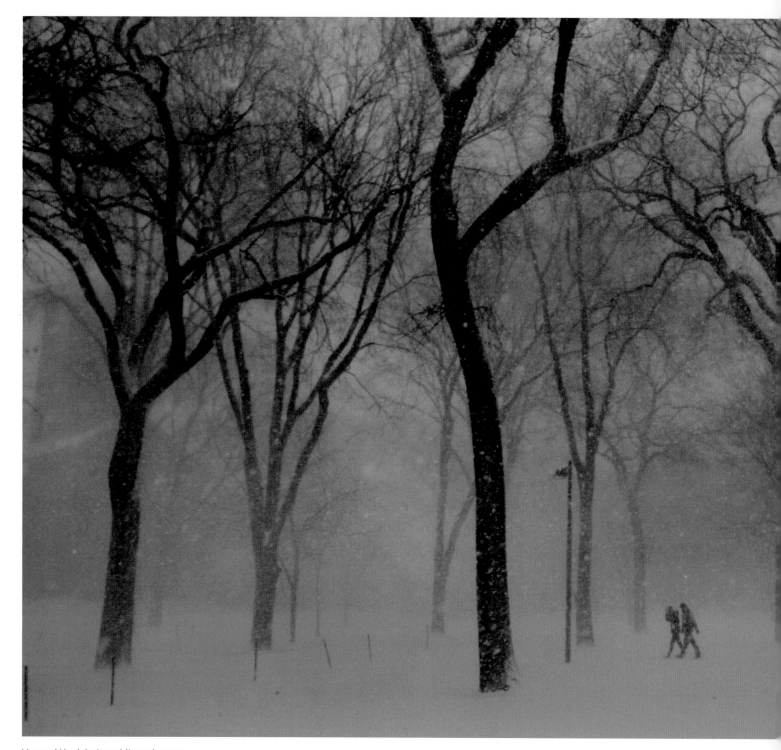

Harvard Yard during a blizzard, 2005

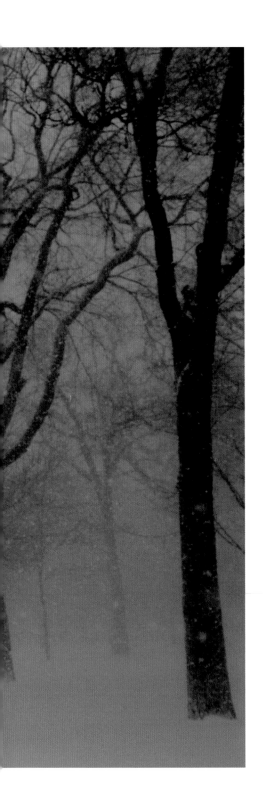

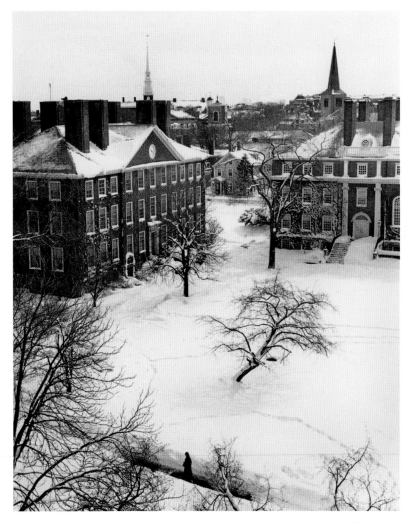

Byerly and Longfellow Halls, 1960

Memorial Church through the crab apple blossoms, 2010

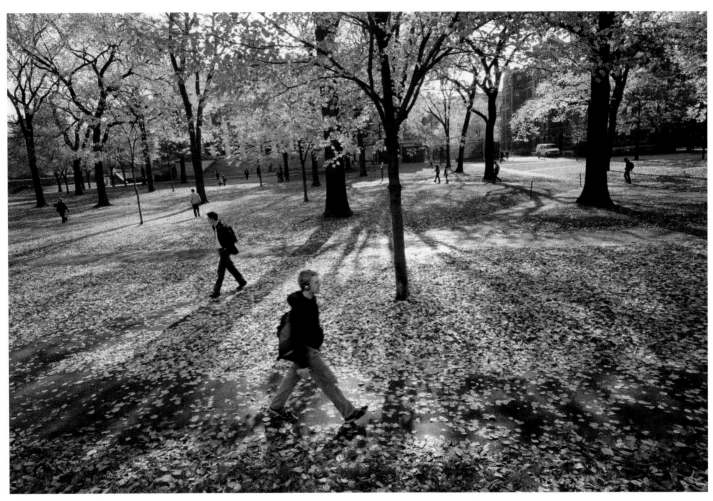

Harvard Yard, 2003

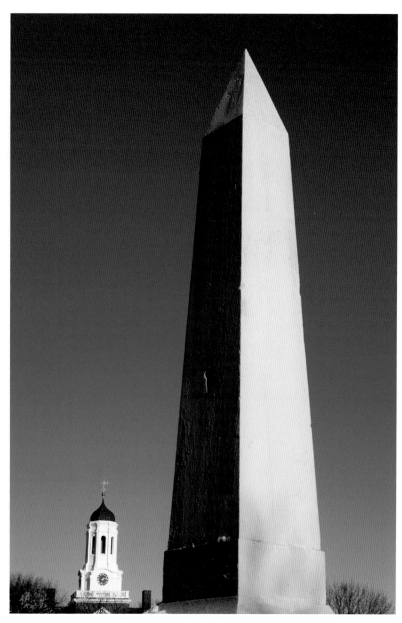

Dunster House and Weeks Footbridge, 2008

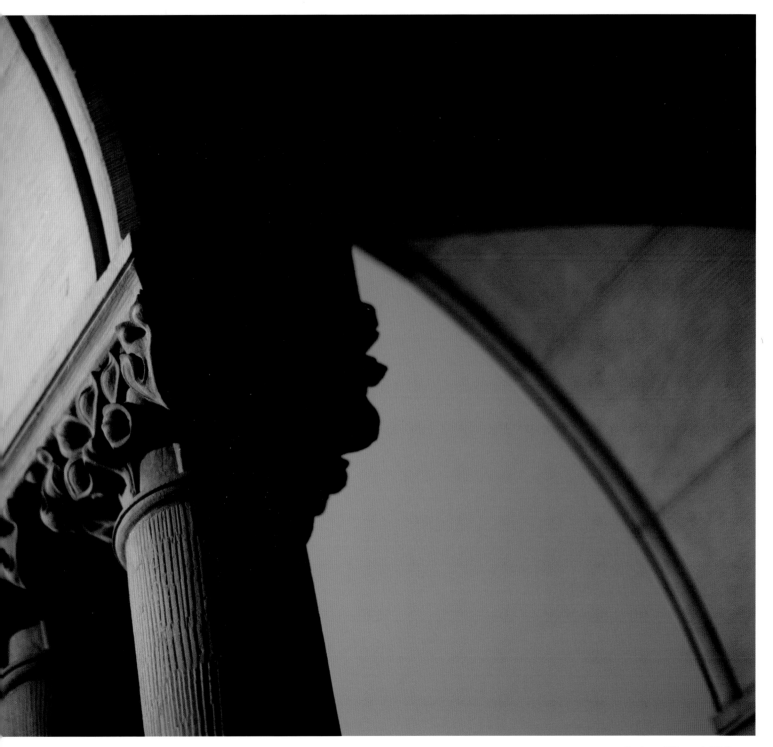

Arches of Memorial Hall, 2010

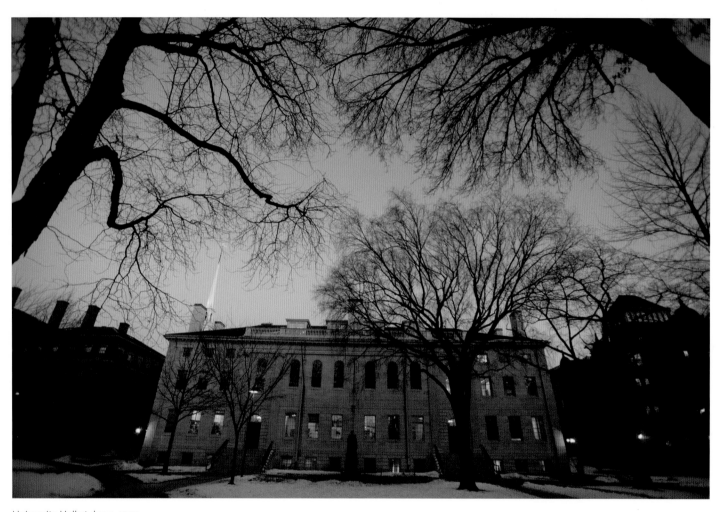

University Hall at dawn, 2010

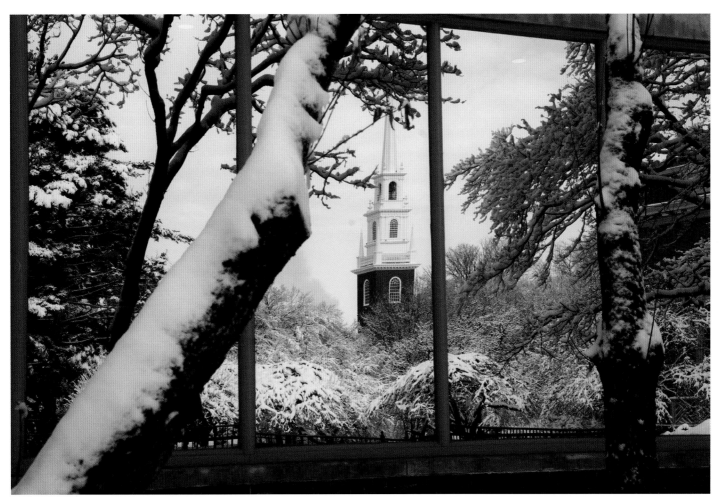

Memorial Church reflected in Lamont Library, 2008

57

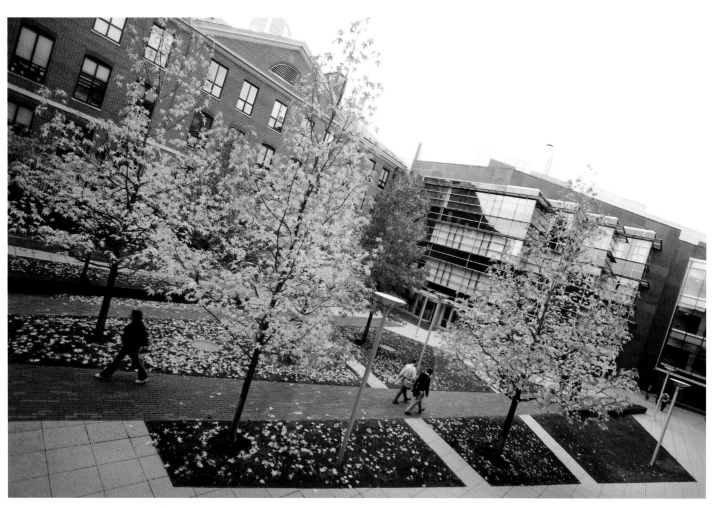

Converse Chemistry and Bauer Laboratories, 2009

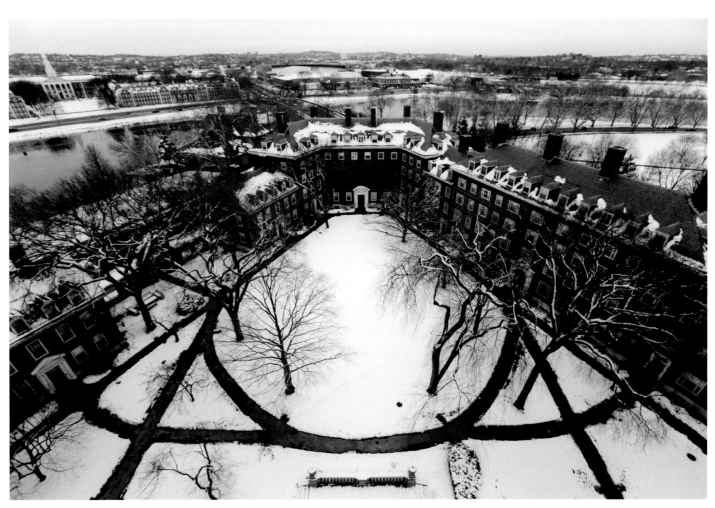

Eliot House Courtyard, 2008

III

The slow overture of rain,
each drop breaking
without breaking into
the next, describes
the unrelenting, syncopated
mind.

<div style="text-align: right">

Jorie Graham,
Boylston Professor of
Rhetoric and Oratory,
from "Mind"

</div>

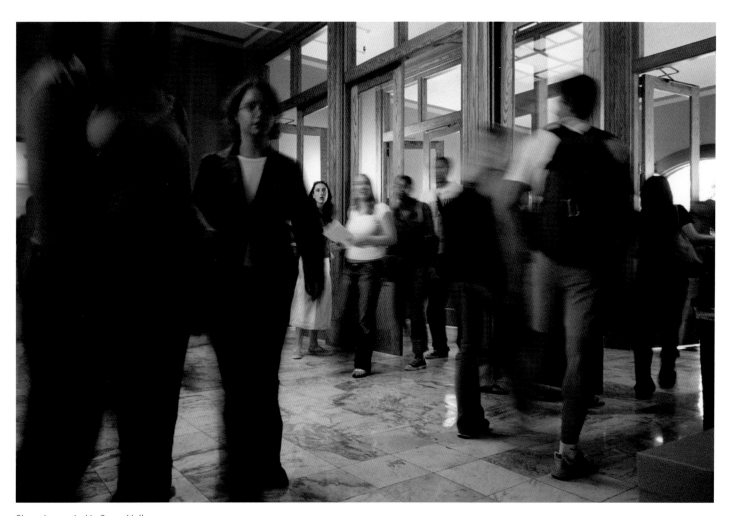

Shopping period in Sever Hall, 2004

In a place where ideas are currency, keys forged in the past unlock the possibilities of the future. The valuable does not overshadow the invaluable, and discovery has a common goal across the sciences and the humanities: making sense of the world we navigate together. A robust investment in financial aid ensures that talented students from all walks of life and every corner of the planet congregate in lecture halls to learn about moral justice or gather in the laboratory to witness the transfer of nuclei between stem cells. They peer into the night sky to study the rings of Saturn, or tuck themselves into library carrels to ponder the moons of poetry. The discussion moves easily from politics to archaeology, and pens and paper are exchanged for spades and shovels, as scholars and students pick over the world of knowledge with an unbounded curiosity in the ever-widening search for understanding.

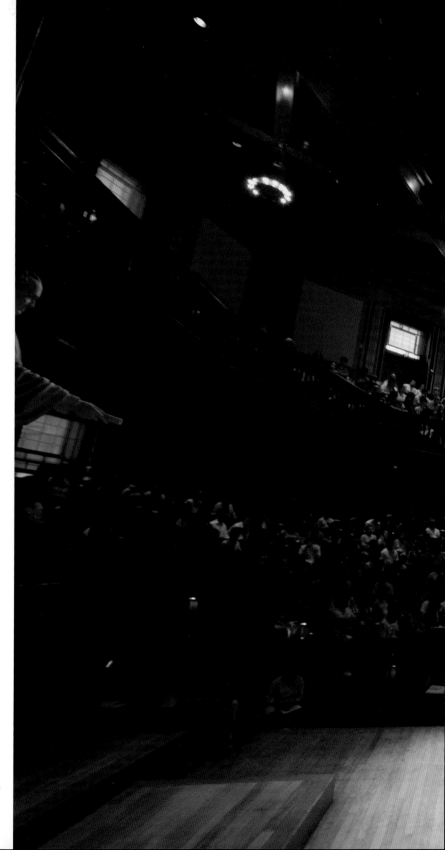

Teaching Justice in Sanders Theatre, 2008

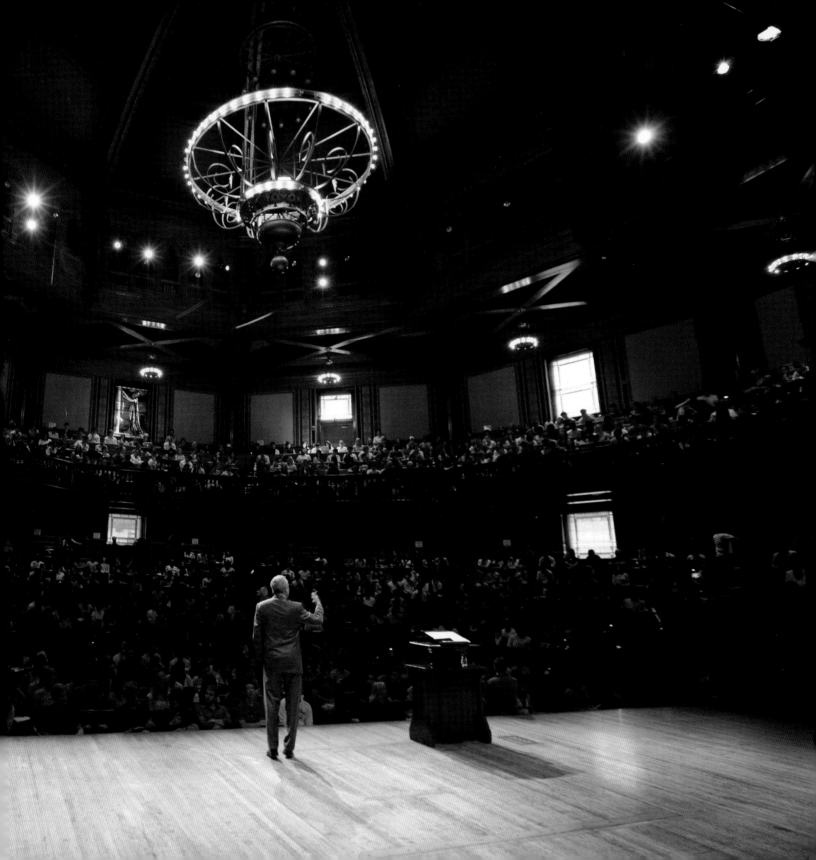

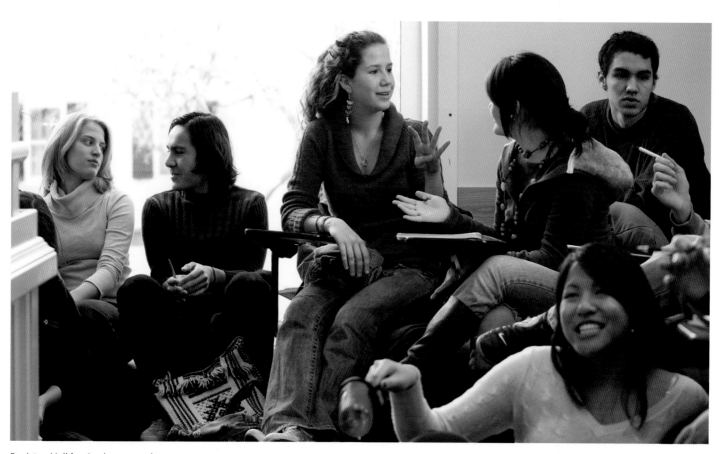

Boylston Hall foreign language class, 2007

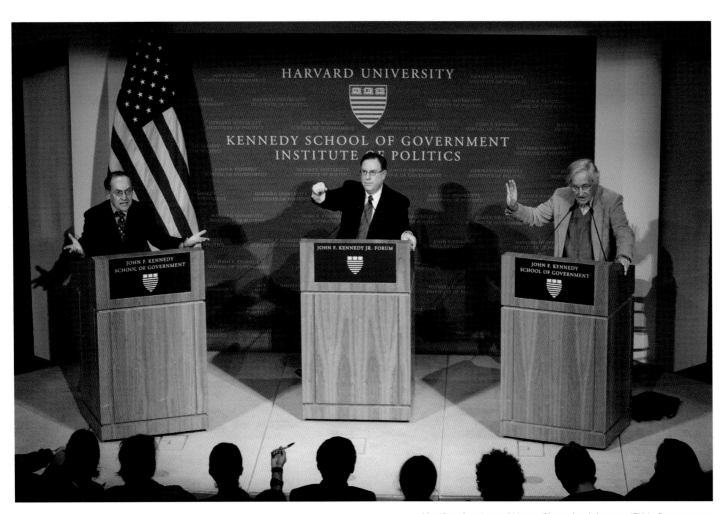

Alan Dershowitz and Noam Chomsky debate at JFK Jr. Forum, 2005

Engineering miniature flying vehicles, 2010

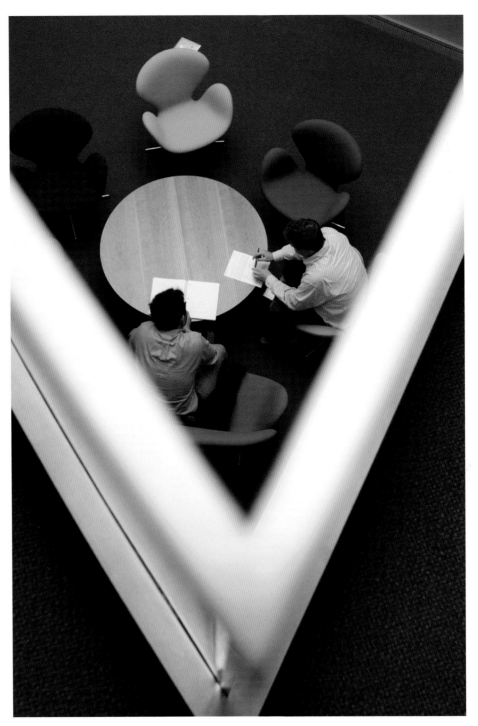

69

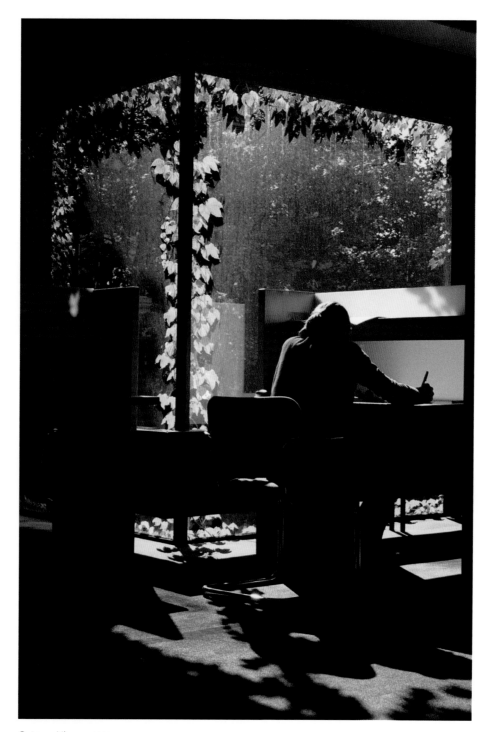

Gutman Library, 2003

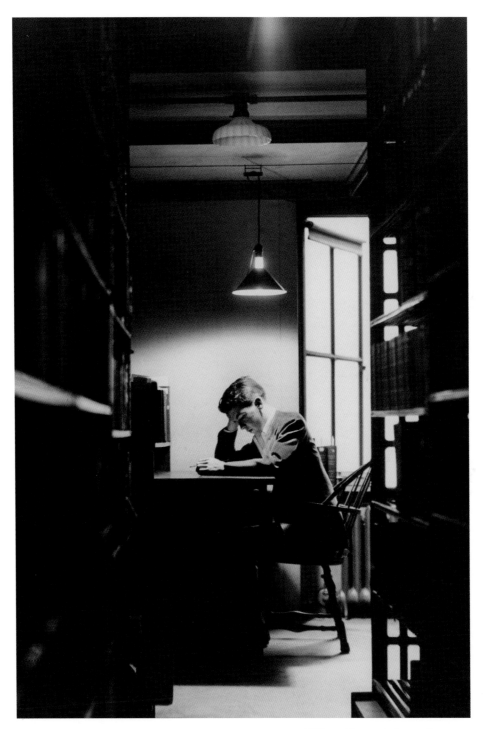

Widener Library study carrel, ca. 1942

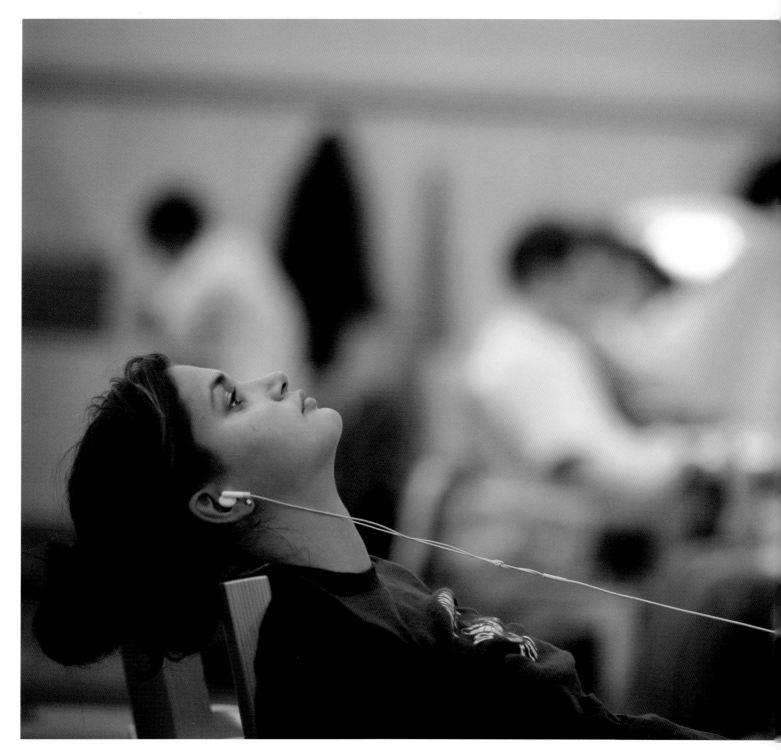

72

Nearing midnight at Lamont Library, 2006

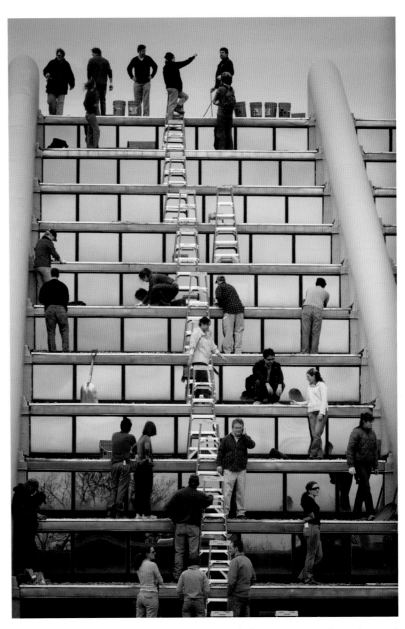

Graduate School of Design green roof exercise, 2006

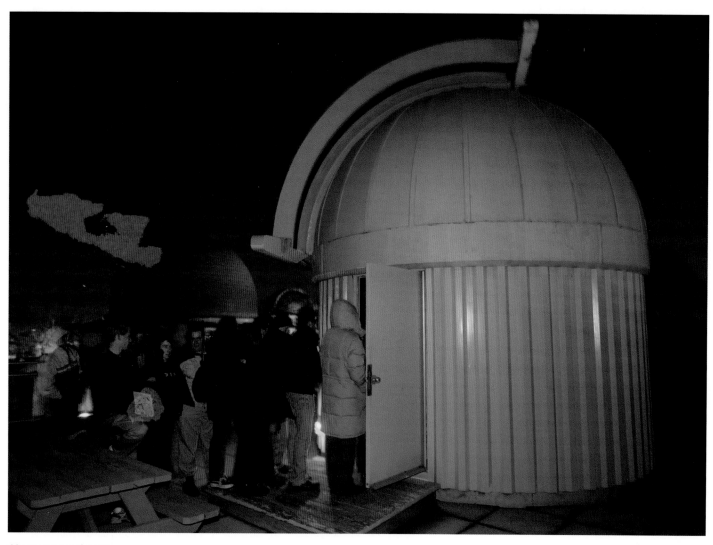

Observatory roof, 2002

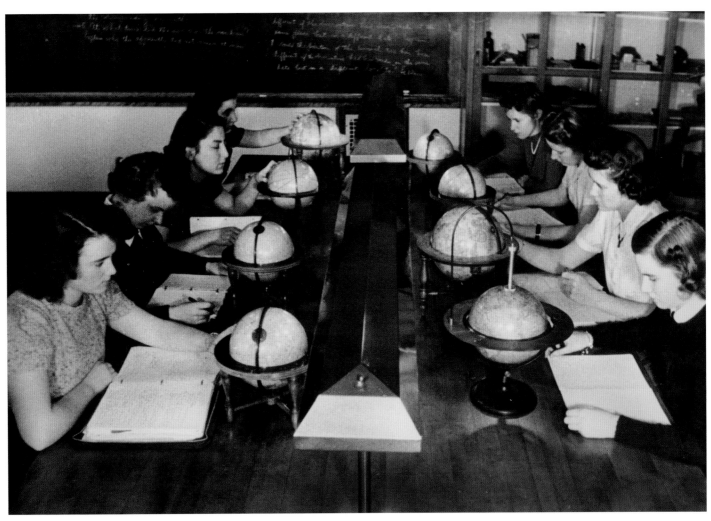

Astronomy class at Radcliffe College, 1947

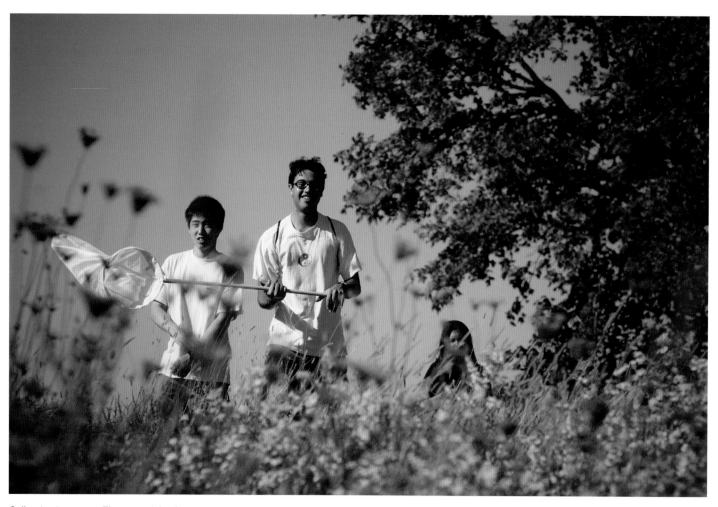

Collecting insects on Thompson Island in Boston Harbor, 2006

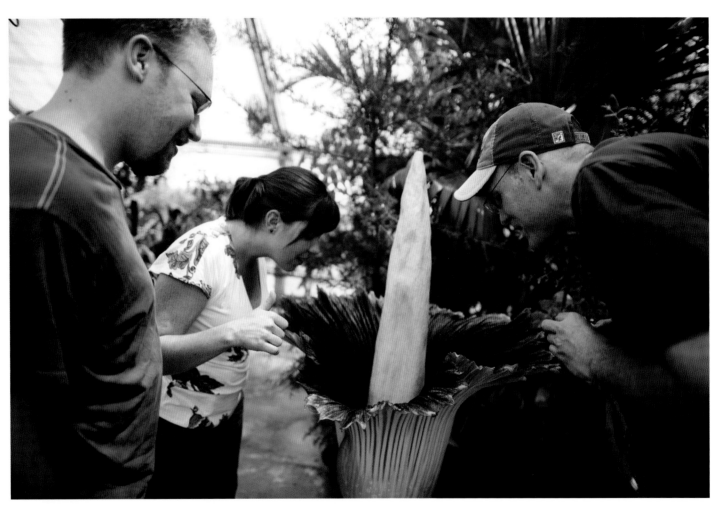

Titan arum plant blooms atop the Biological Laboratories, 2010

Harvard Yard archaeological dig, 2009

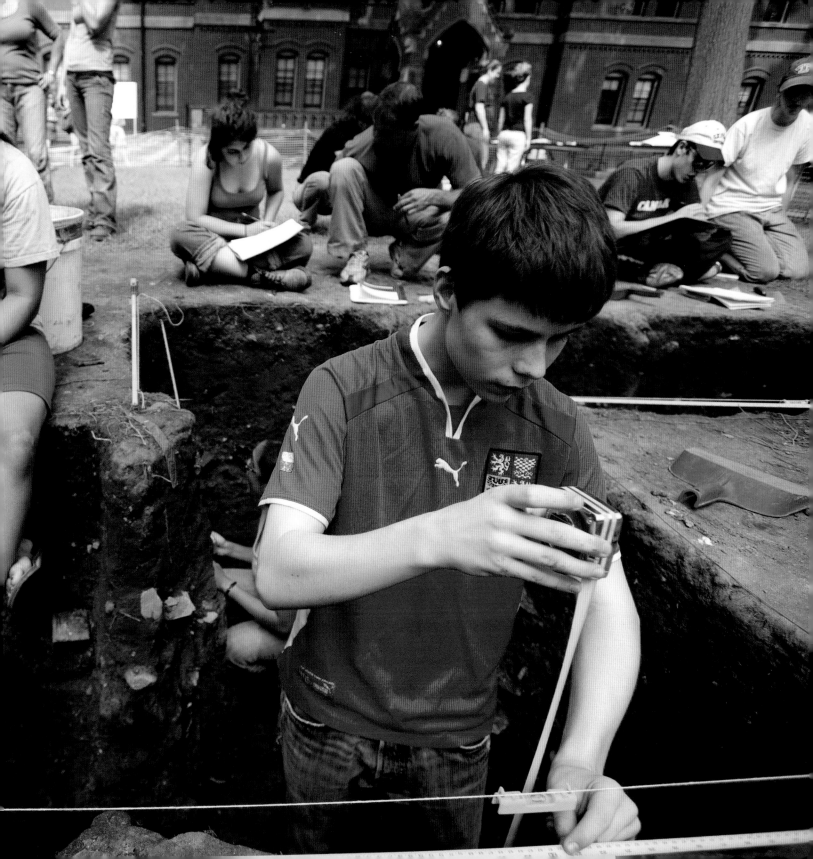

Memorial Hall seminar, 2009

Edwin O. Reischauer teaches Intensive Intermediate Japanese seminar, 1961

Ted Sorensen speaks at JFK Jr. Forum, 2007

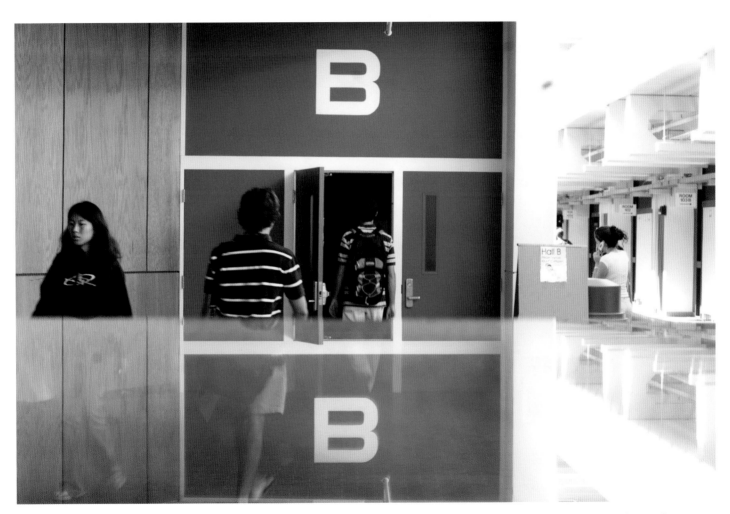

Science Center, 2005

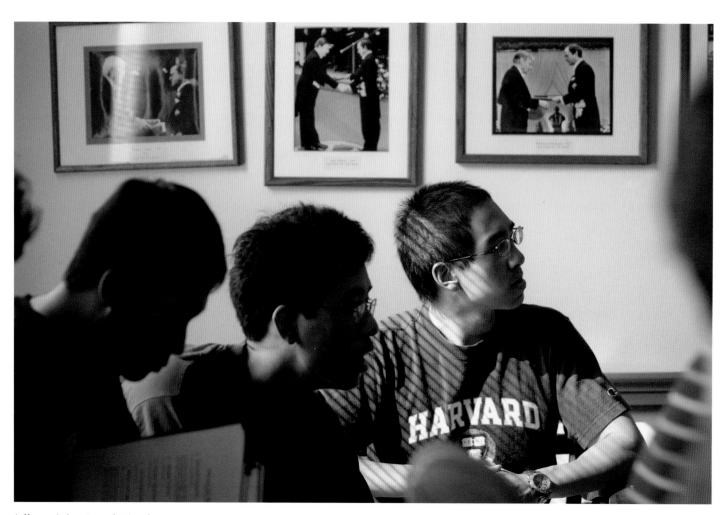

Jefferson Laboratory physics class, 2007

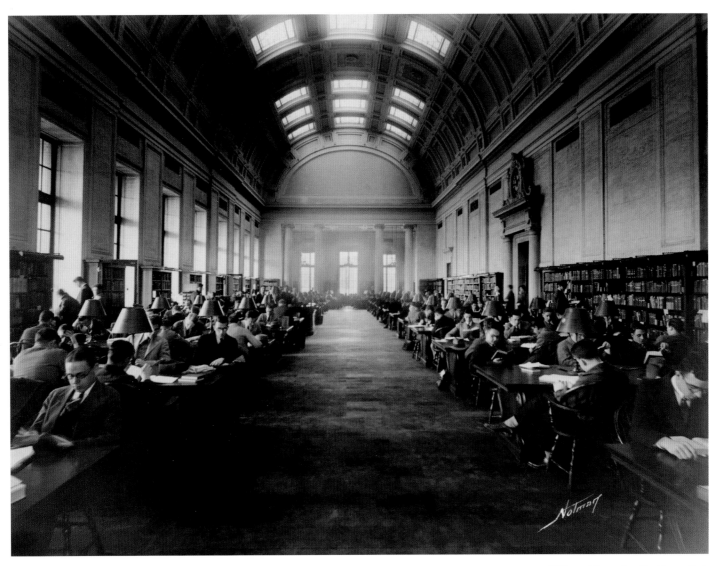

Widener Library Reading Room, 1927

Author Geraldine Brooks speaks at the Radcliffe Institute, 2006

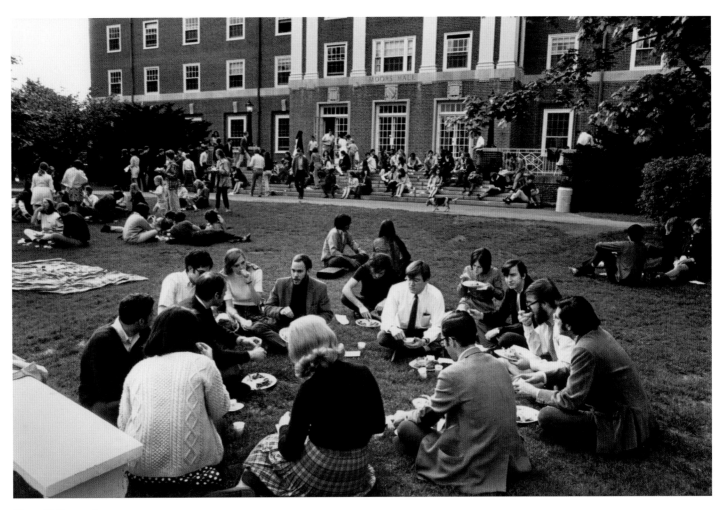

Moors Hall, ca. 1965

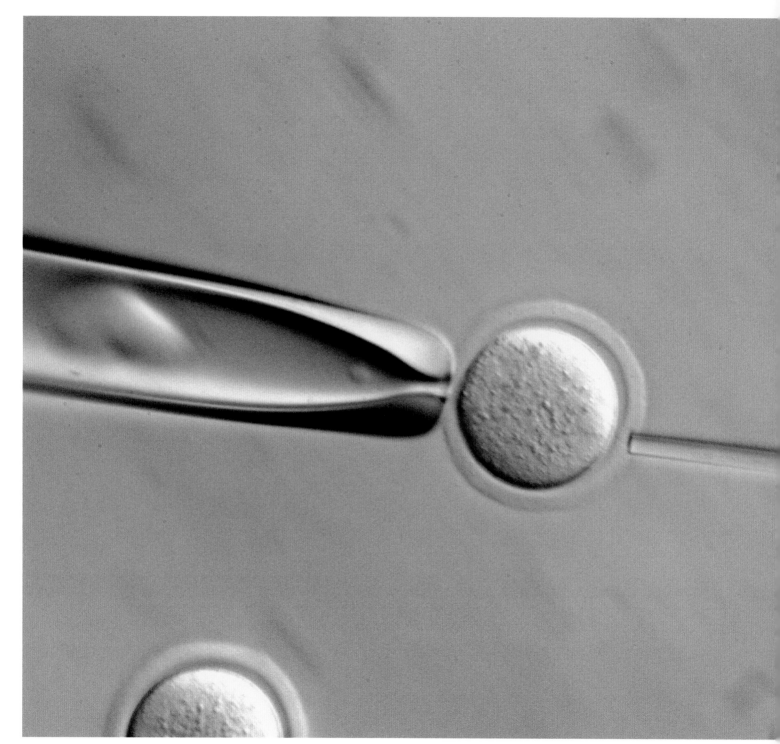

Nuclear transfer to create customized stem cells, 2005

Students emerge from Sever and Emerson Halls, ca. 1950

I V

The people who come here also
flow: their bodies becoming
nebulous, diffused, quietly
spreading out into the air across
these interstellar sidewalks.

Margaret Atwood,
M.A. '62, Litt. D. '04,
from "A Place: Fragments"

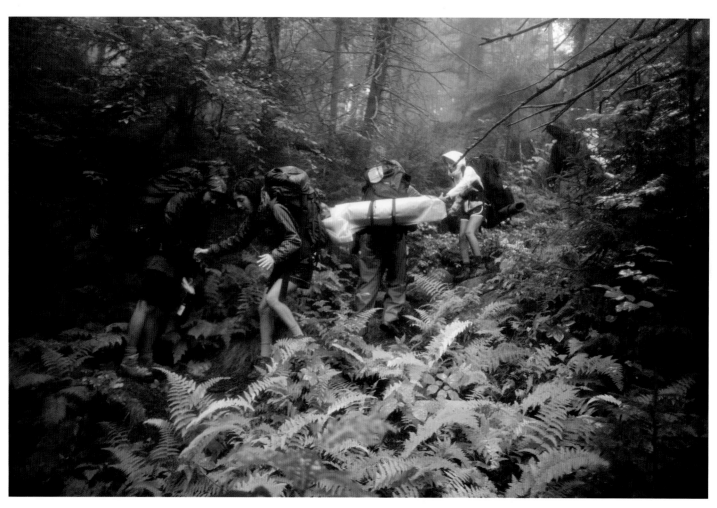

First-Year Outdoor Program, 2010

An education is more than what you acquire in the classroom. It's also the product of what you do between the library and the lecture hall, and the people you meet in the dining hall or floating on inner tubes during a screening of *Jaws* at the Malkin Pool. Faculty and students live and learn together at Harvard in a comprehensive house system that nurtures relationships often forged in extracurricular activities that introduce students to public service, encourage them to pursue their passion for the arts, showcase their agility on the playing field, or satisfy their curiosity about journalism, theater, music, or politics. After Commencement, a student may realize that the path her life followed was influenced as much by the friendships she formed while hiking through a New England forest or cultivating a community garden on campus as it was by the lessons she learned in a biochemistry lab.

94

Freshman Arts Program set design, 2010

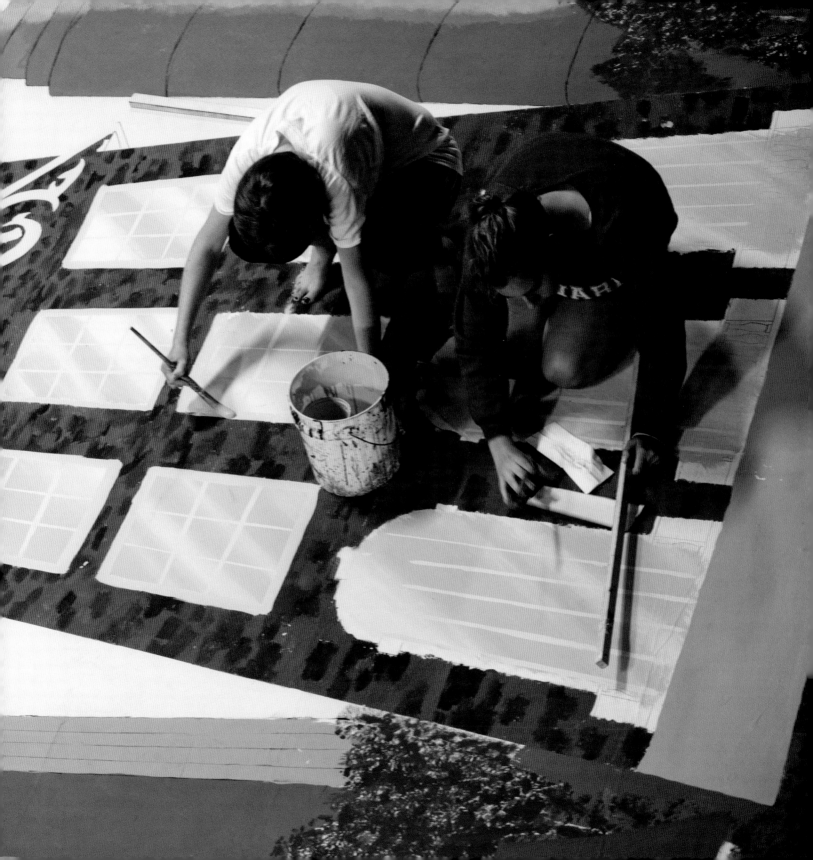

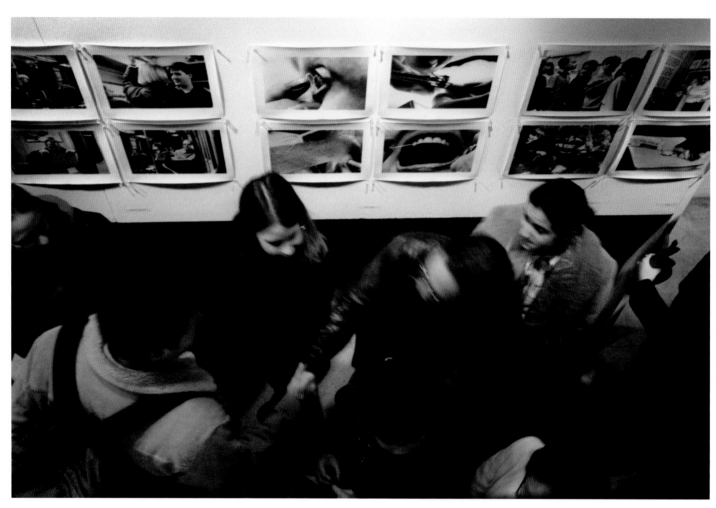

Carpenter Center photography opening, 2002

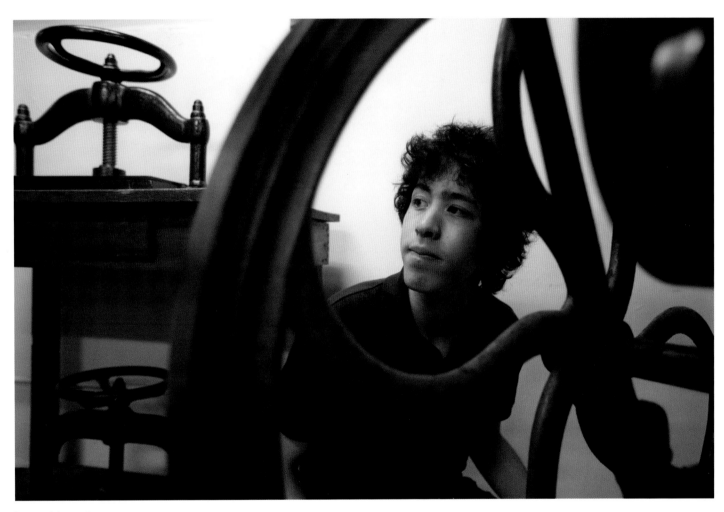

Bow and Arrow Press, 2010

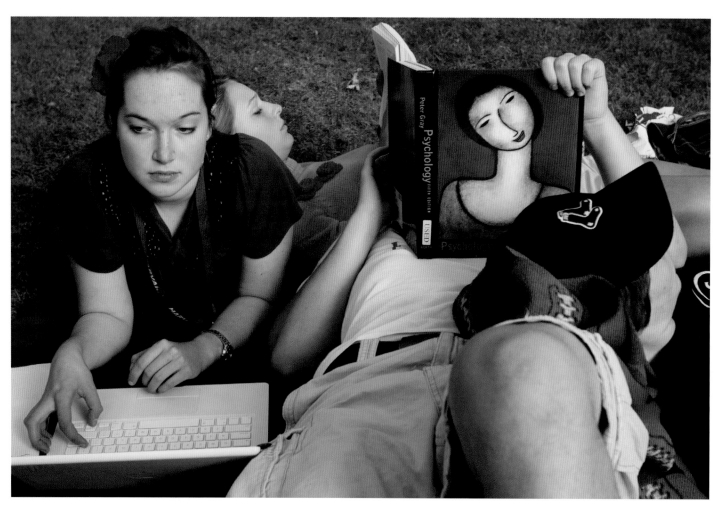

Reading in Harvard Yard, 2009

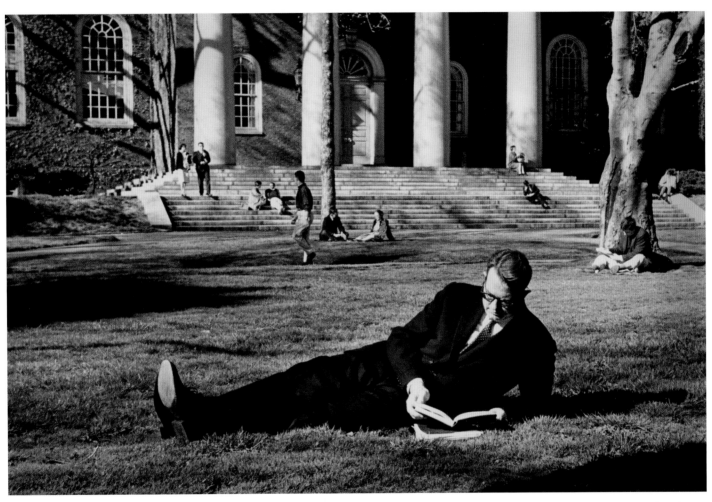

Reading in Harvard Yard, 1960

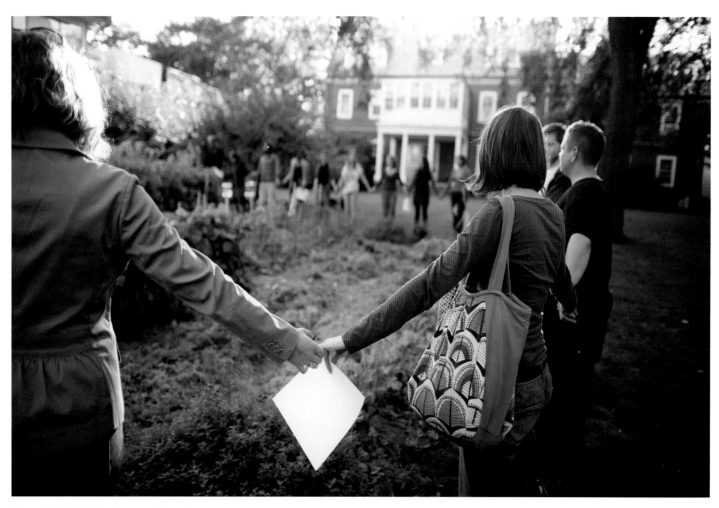

Harvard Divinity School community garden, 2010

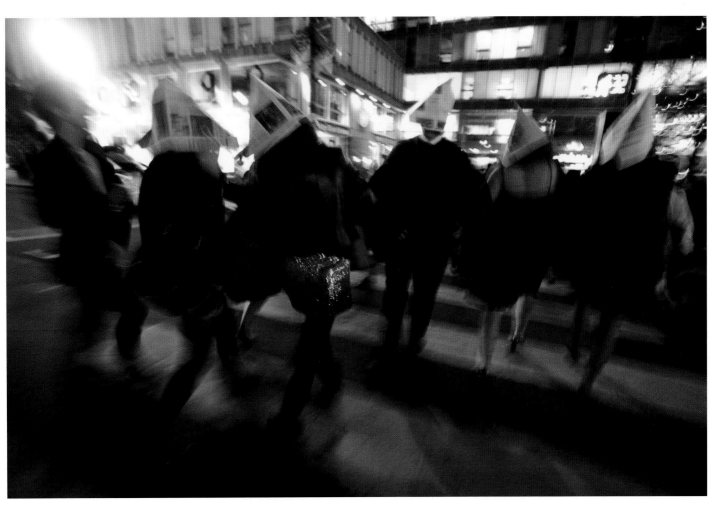

Harvard Crimson writers' initiation, 2009

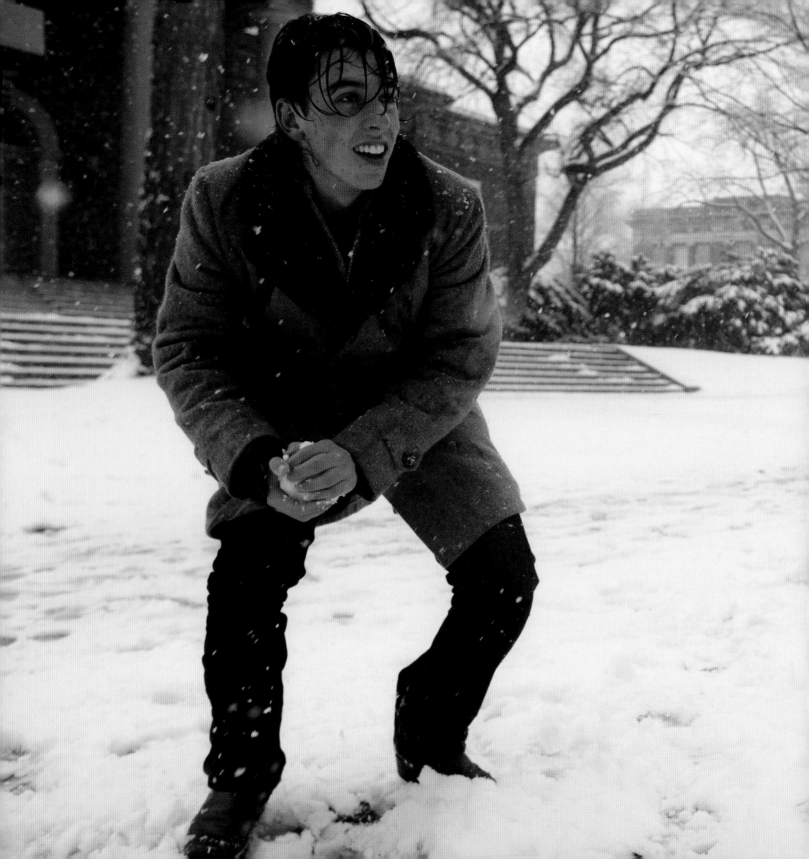

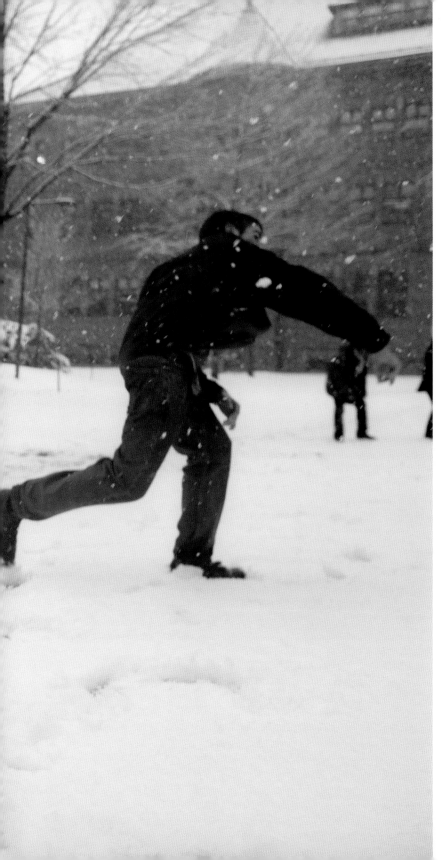

103

Snowball wars in Harvard Yard, 2010

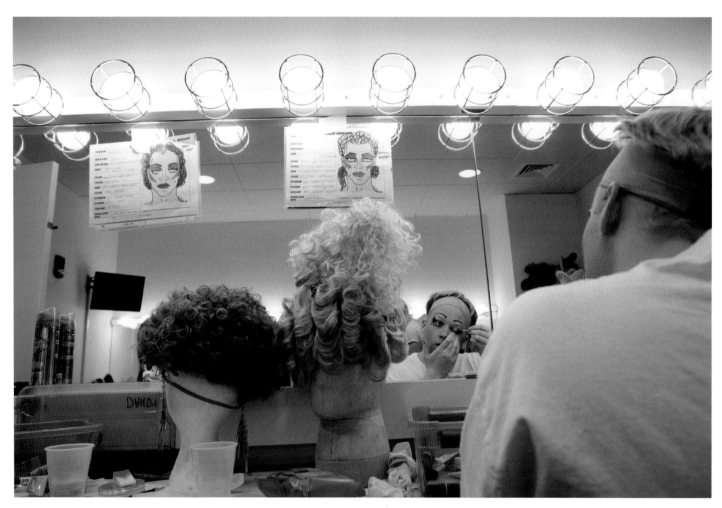

Backstage at the Hasty Pudding Theatricals, 2009

104

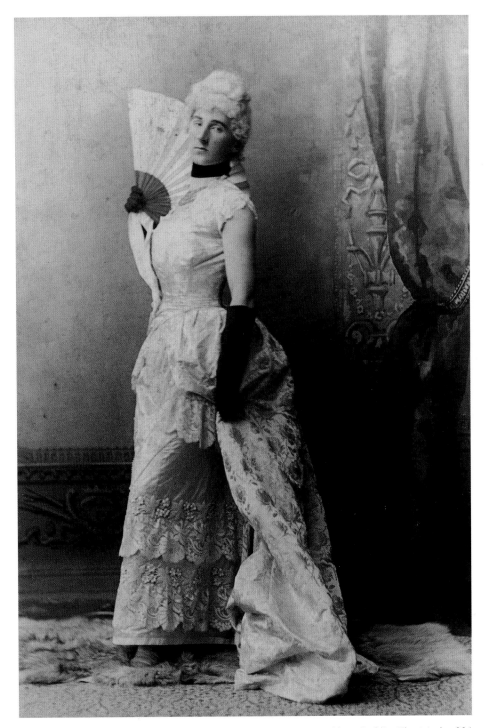

Hasty Pudding Theatricals, 1886

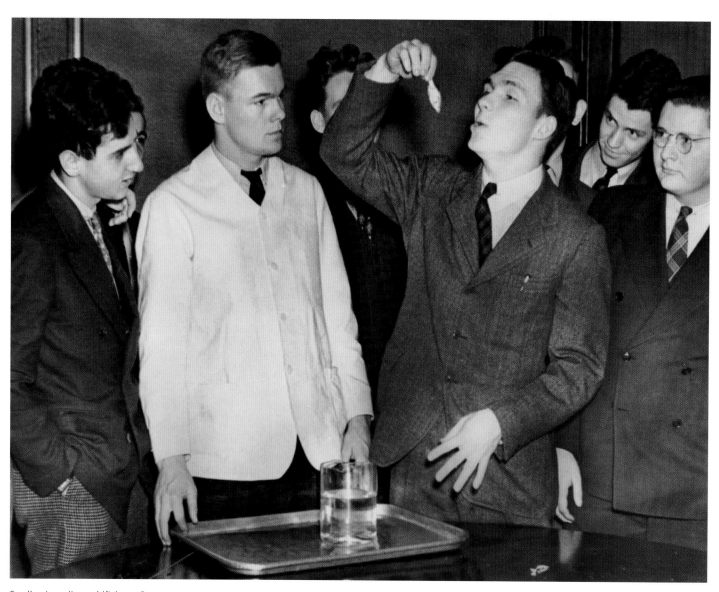

Swallowing a live goldfish, 1938

Annenberg Hall costume catwalk, 2009

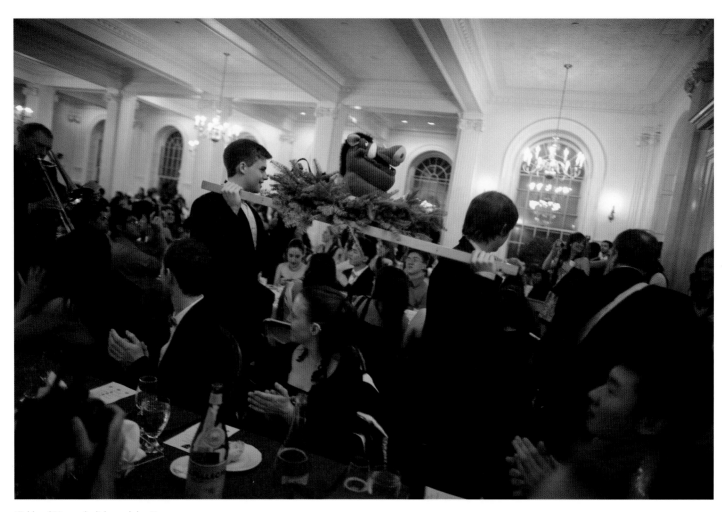

Kirkland House holiday celebration, 2010

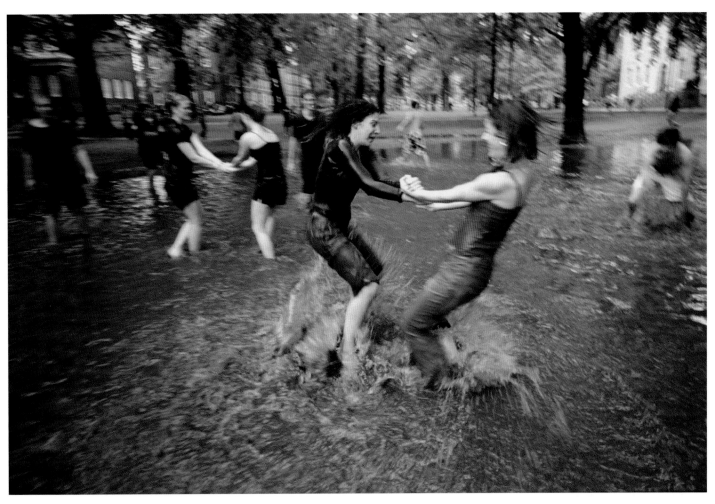

Frolicking in the mud, Harvard Yard, 2003

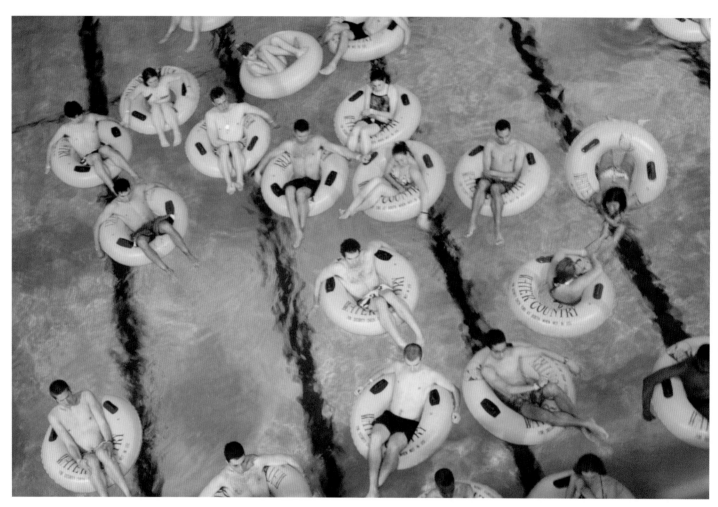

Watching *Jaws* in the Malkin Athletic Center pool, 2006

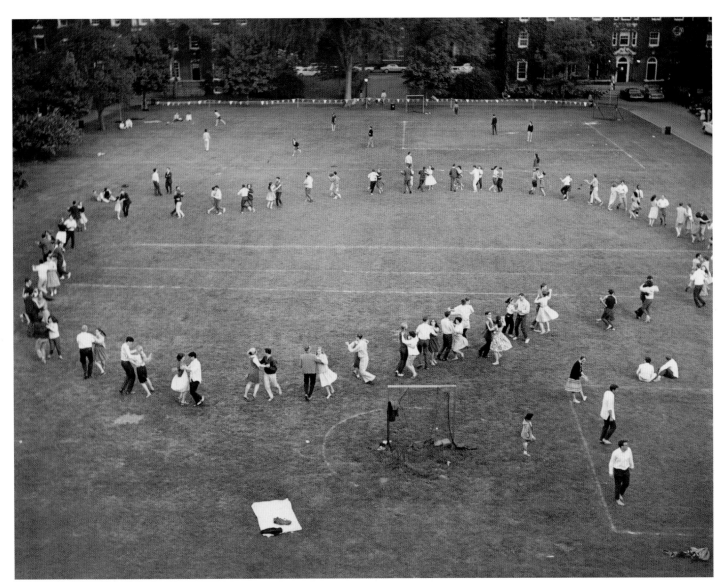

Field Day at Radcliffe College, 1965

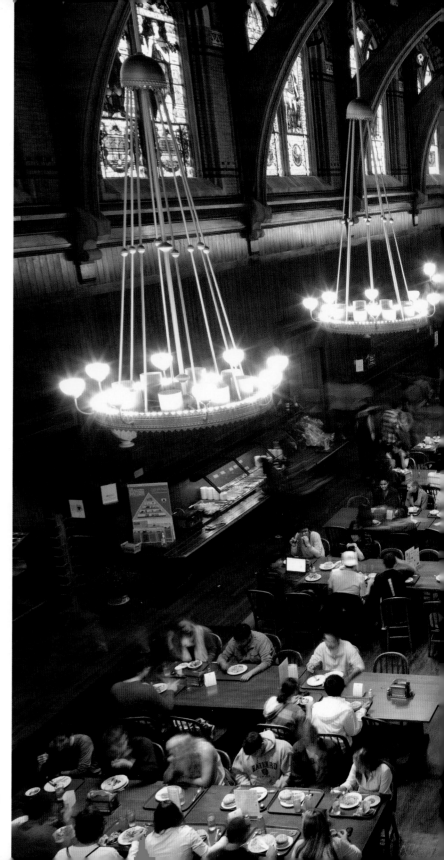

112

The grandeur of Annenberg Hall, 2009

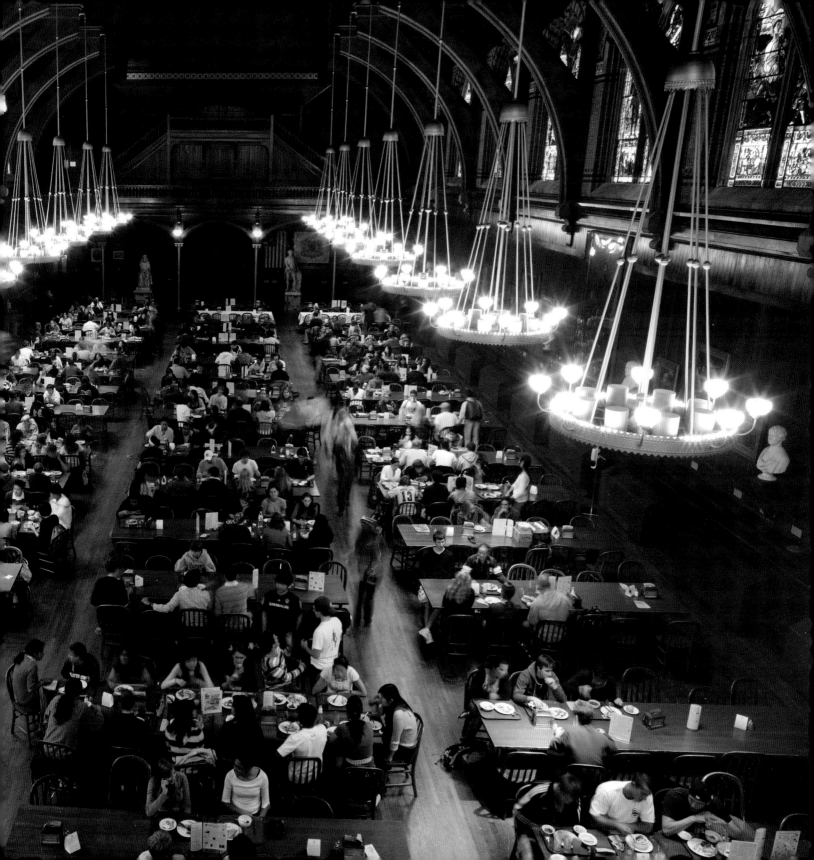

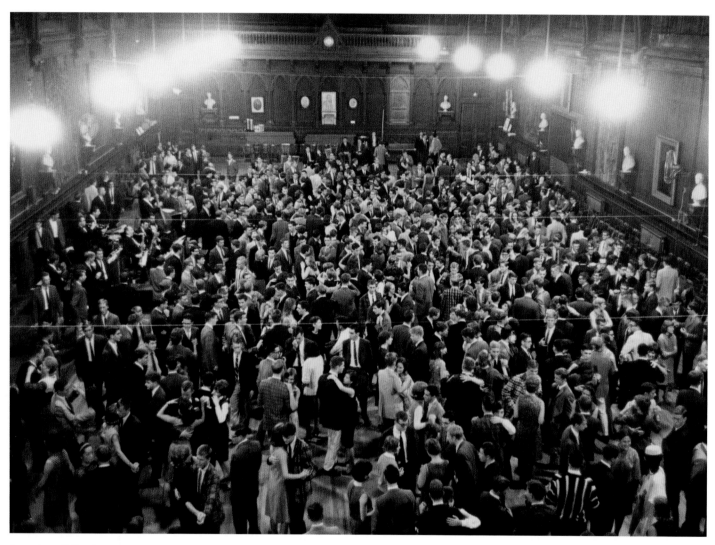

Annenberg Hall, 1964

Freshman study break in Annenberg Hall, 2004

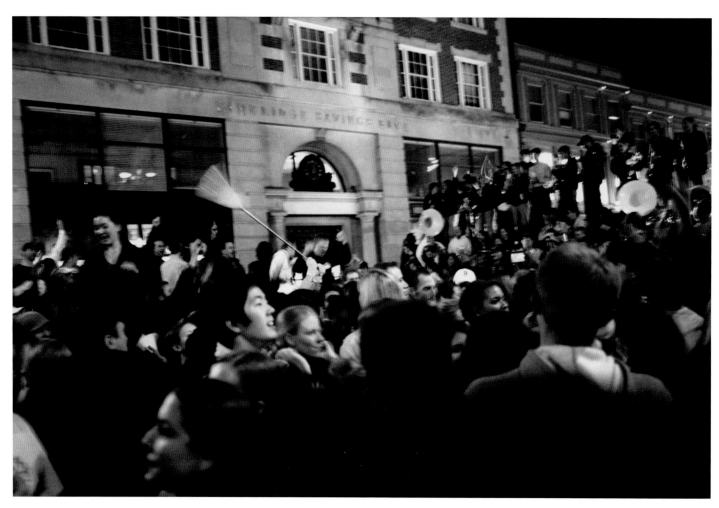

Red Sox World Series celebration in Harvard Square, 2004

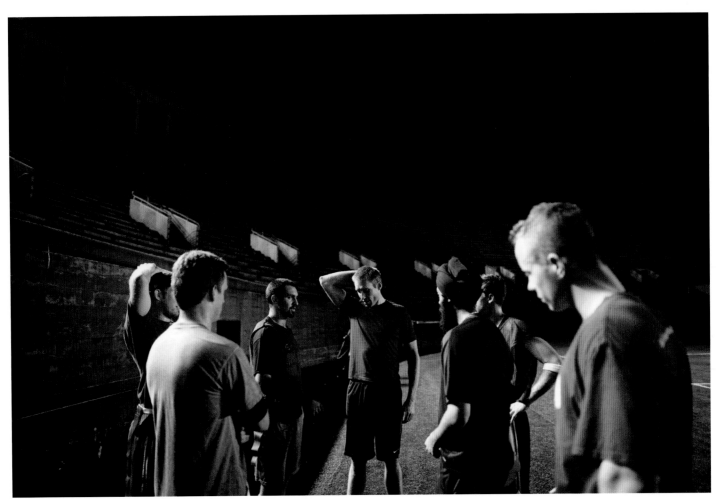

Intramural sports in Harvard Stadium, 2010

V

"We sang them to naps told stories made
shadow-animals with our hands

wiped human debris off boots and coats
sat learning by heart the names
some were too young to write
some had forgotten how"

Adrienne Rich, A.B. '51, Litt. D. '90,
from "The School Among the Ruins"

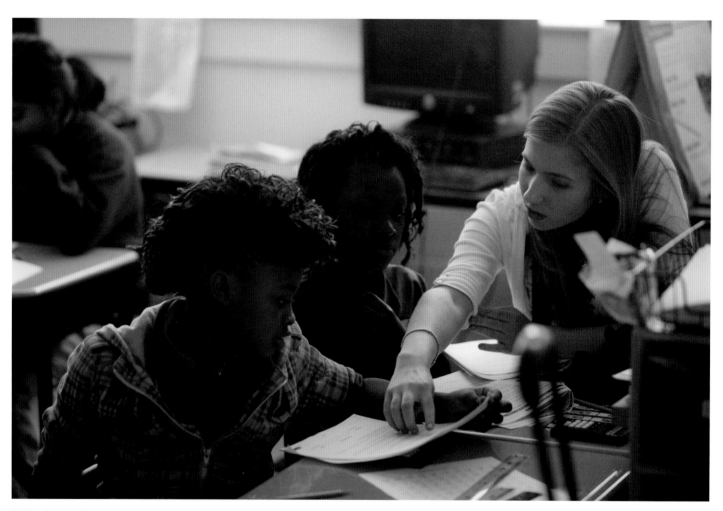

Phillips Brooks House Association Alternative Spring Break in New Orleans, Louisiana, 2010

Harvard is Harvard, in part, because of its reach beyond the Yard. How do you measure that reach? In an increasingly globalized world, the University welcomes a fifth of its students from abroad, and its more than 360,000 living alumni can be found on every continent. Its schools and research centers have offices in nine countries. But the reach of a premier research university is felt beyond the numbers. Knowledge is power only when it is exercised, and the power of Harvard is manifest through faculty members deciphering Maya glyphs in Mexico and glimpsing new solar systems light years away from Earth, graduates entering public service, undergraduates dedicating their spring breaks to rebuilding churches in the South or helping inner-city youths learn to read and write, and by researchers combating the spread of AIDS and tuberculosis in some of the poorest parts of the planet. Is the measure of Harvard to be taken by the number of its graduates who become heads of state or by the doctor caring for an ailing infant in Africa who, but for a program initiated by the University and its affiliates, would have gone unattended?

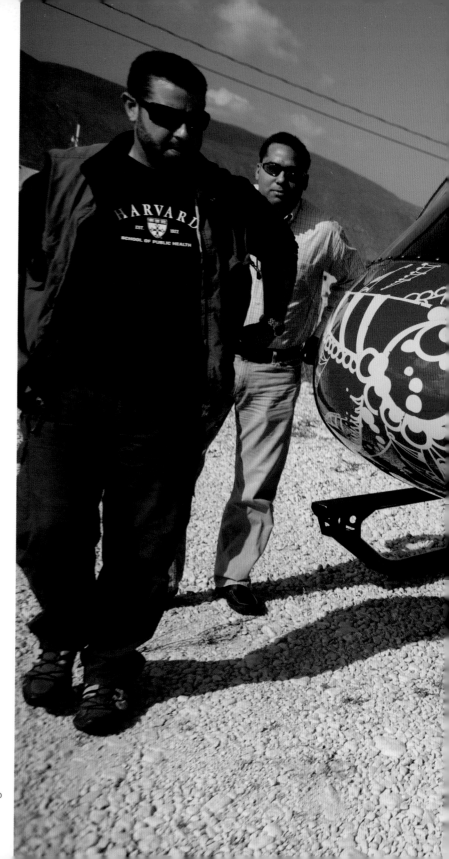

Harvard Humanitarian Initiative in Haiti, 2010

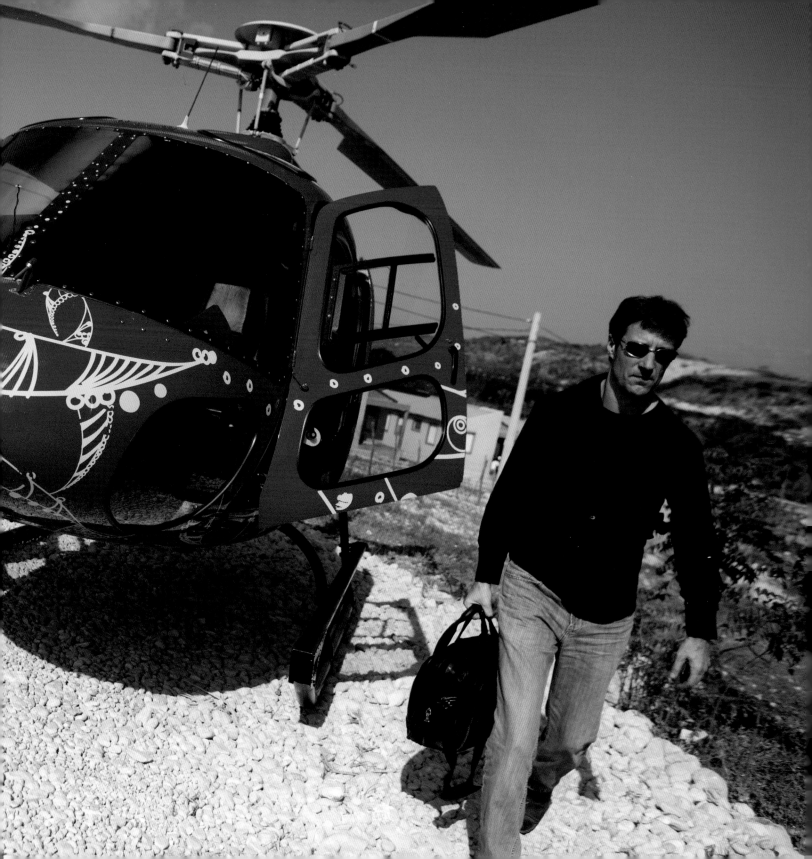

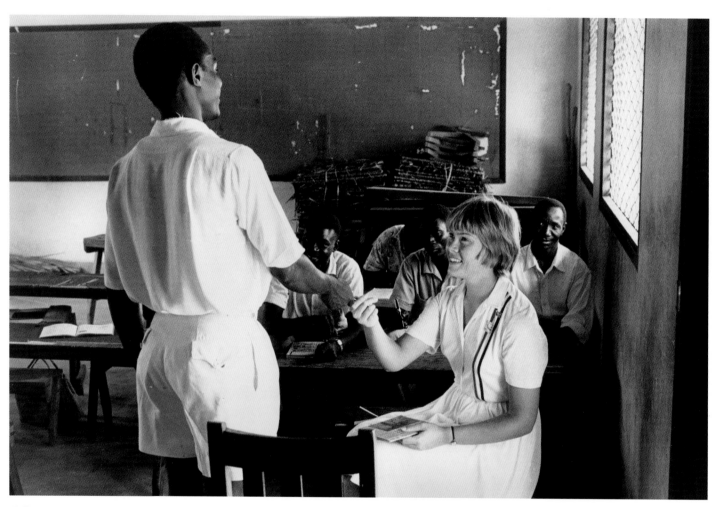

Phillips Brooks House Association in Tanganyika (now Tanzania), ca. 1962

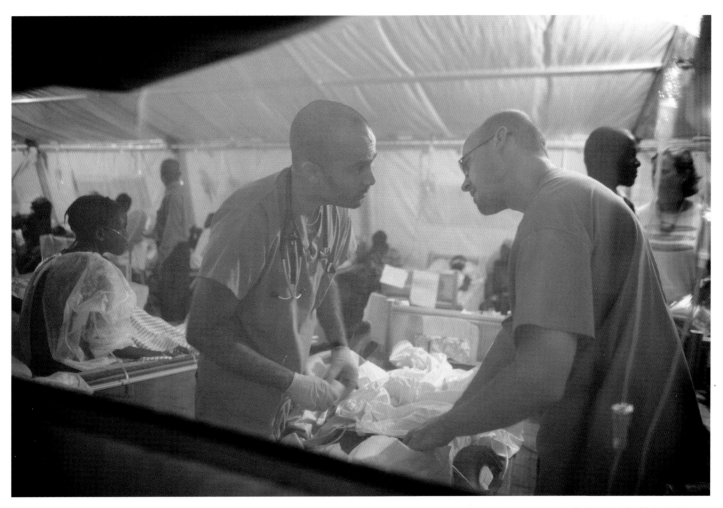

Partners in Health in Haiti, 2010

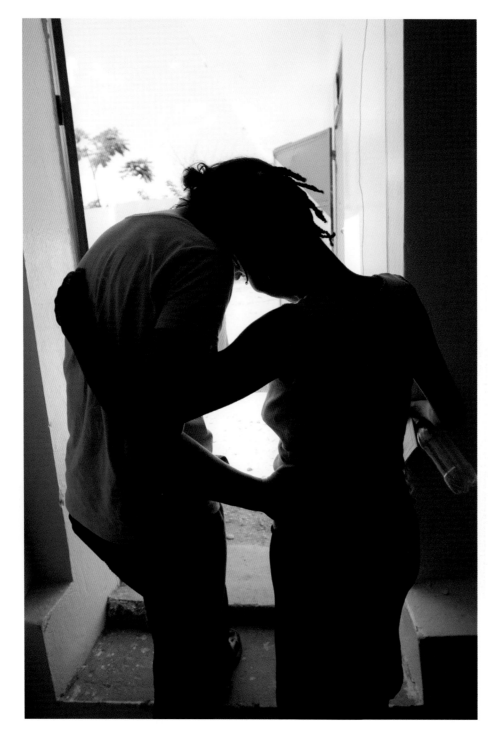

Partners in Health in Haiti, 2008

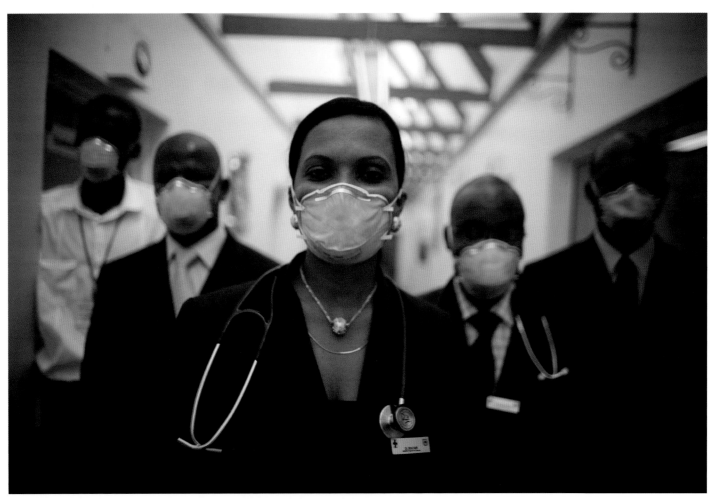

Partners in Health in Lesotho, 2008

Community health work in Lesotho, 2008

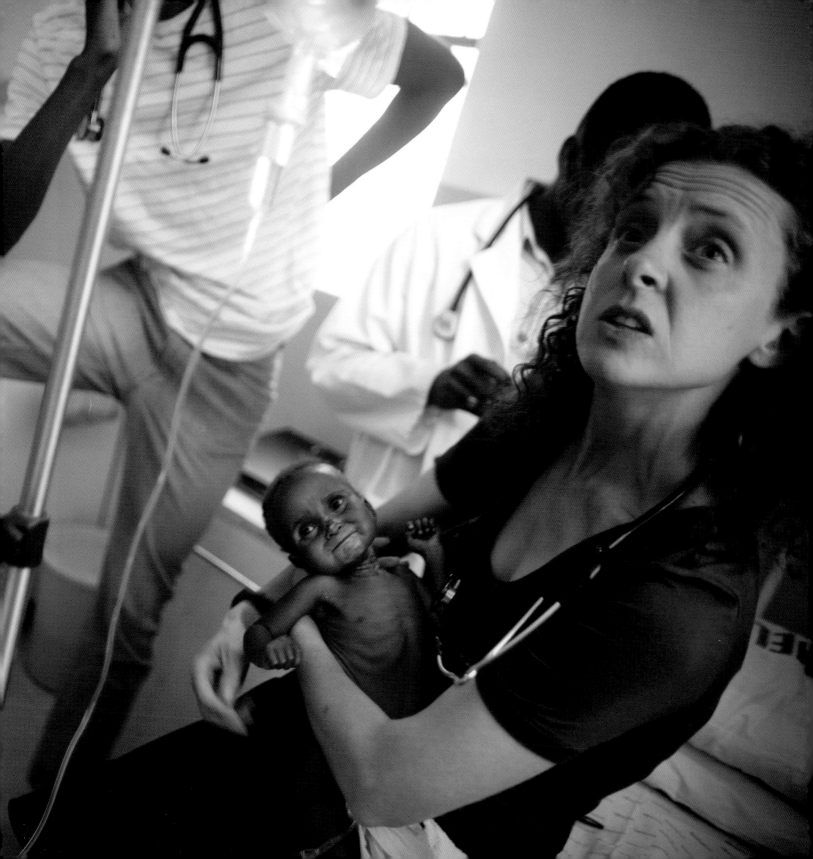

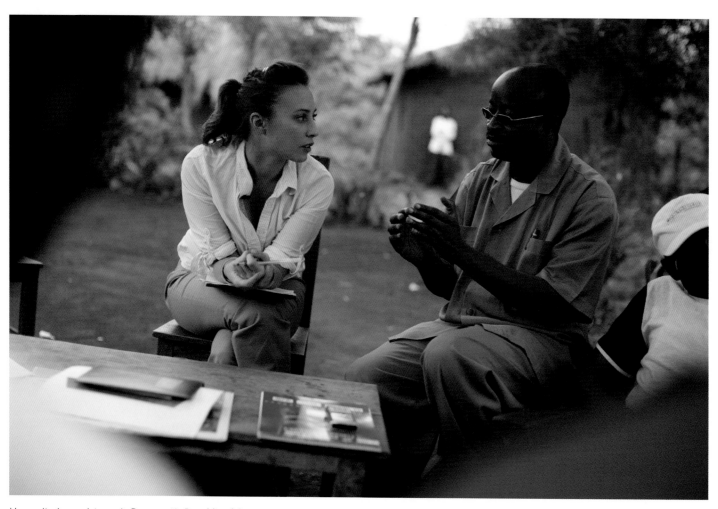

Humanitarian assistance in Democratic Republic of Congo, 2009

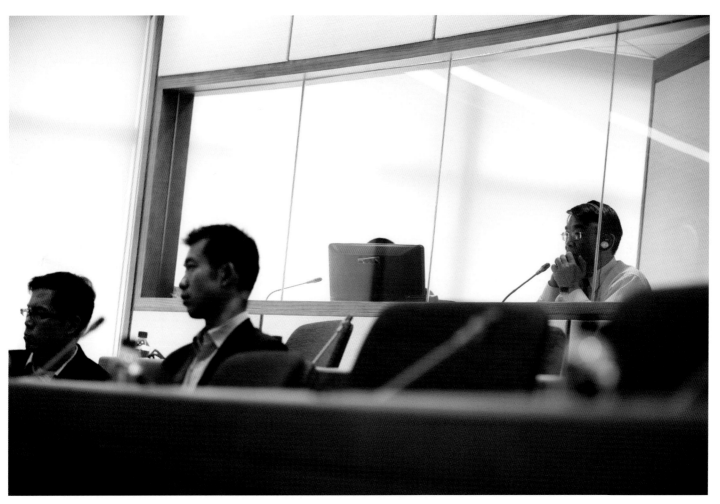

Harvard Center Shanghai in China, 2010

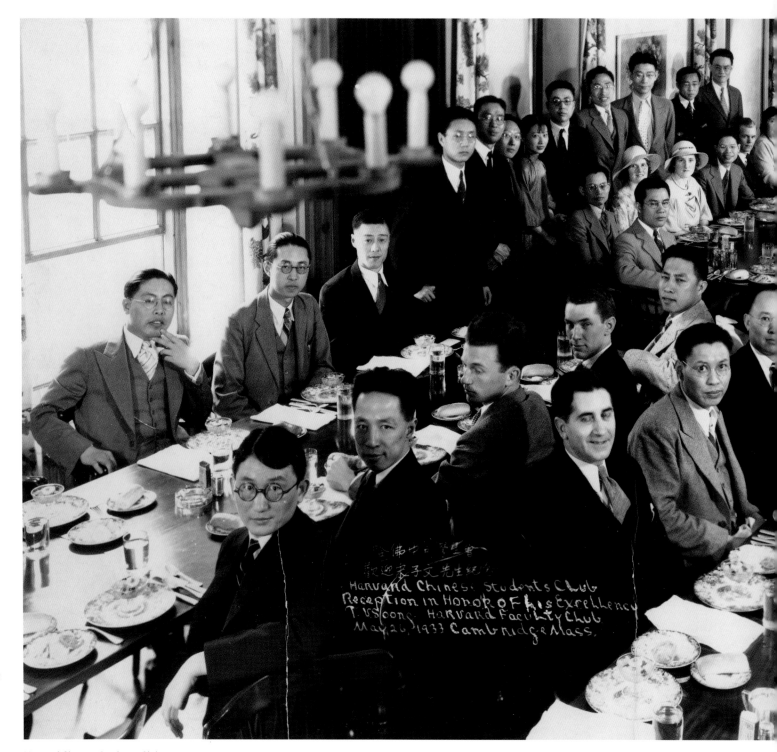

132

Harvard Chinese Students Club, 1933

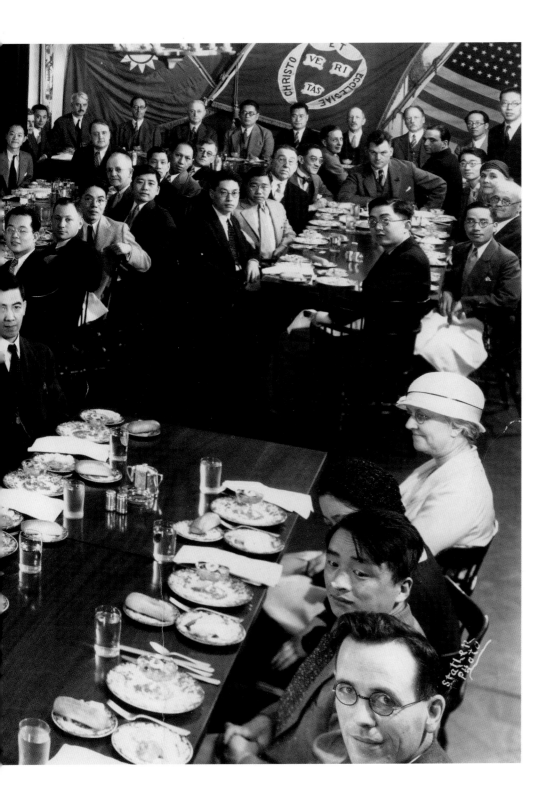

133

Yuetan Community Health Center in China, 2008

Harvard Club of Japan, 2010

Faculty studying the culture of Tsukiji Fish Market in Japan, 2010

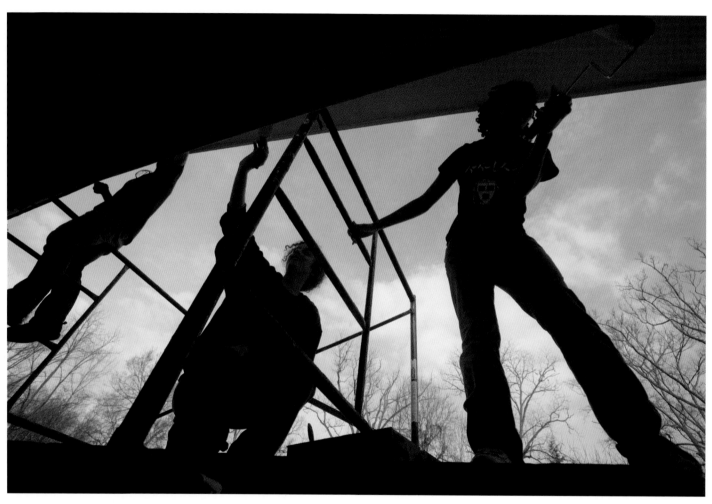

Rebuilding churches in Hayneville, Alabama, 2010

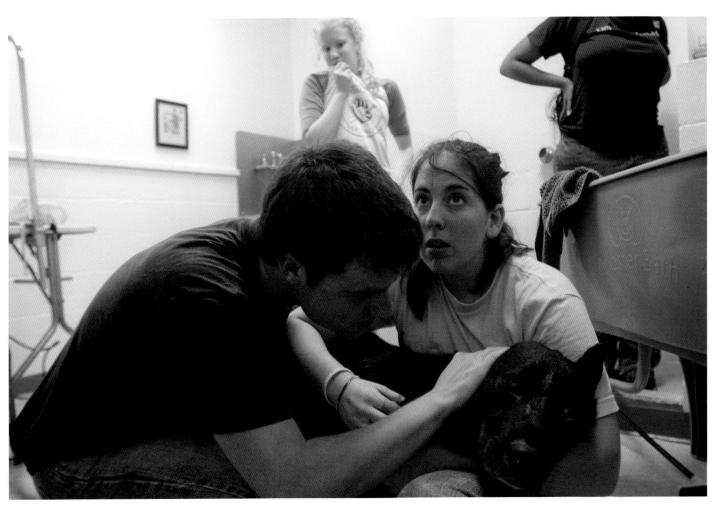

Humane Society work in Gulfport, Mississippi, 2009

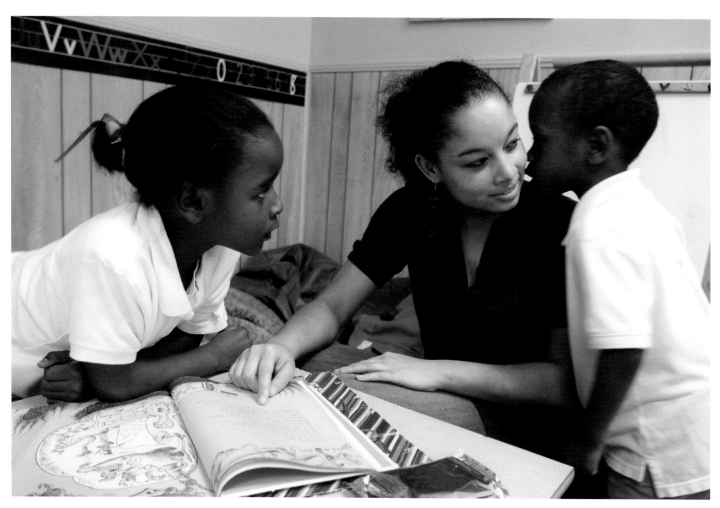

Teaching afterschool in Jackson, Mississippi, 2009

Community work at Roosevelt Towers housing project, Cambridge, Massachusetts, 1965

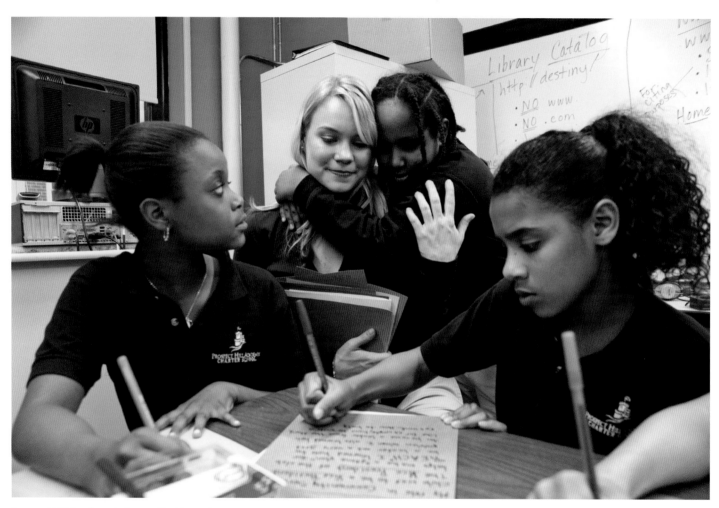

Prospect Hill Academy in Somerville, Massachusetts, 2010

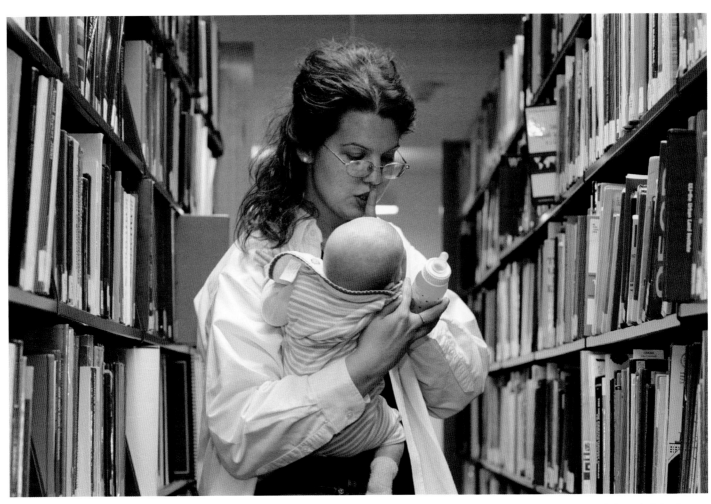

Juggling foster parenting and graduate studies at Harvard Kennedy School, 2004

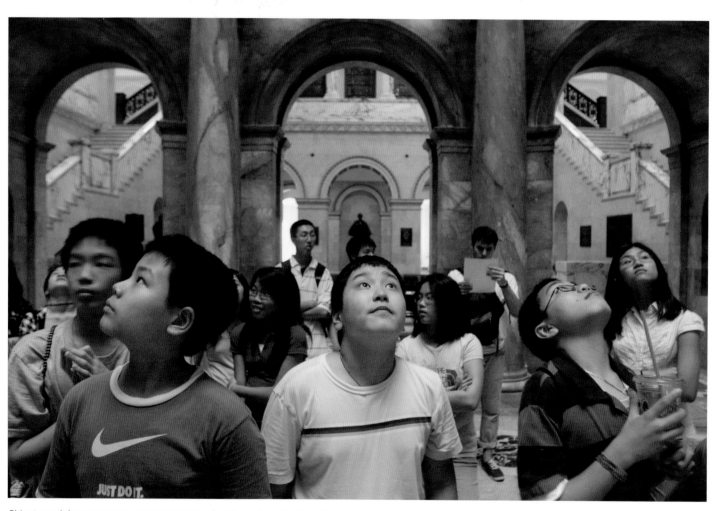

Chinatown Adventure summer program visits the Massachusetts State House, 2009

144

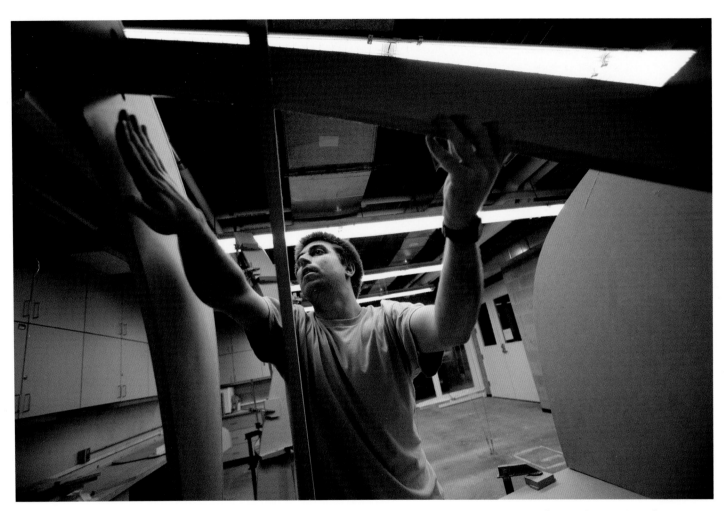

Chinatown library installation in Boston, Massachusetts, 2009

147

Alumni-led Educación Popular en Salud in Chile, 2010

Community health work in Chile, 2010

Emergency relief program in Chile, 2010

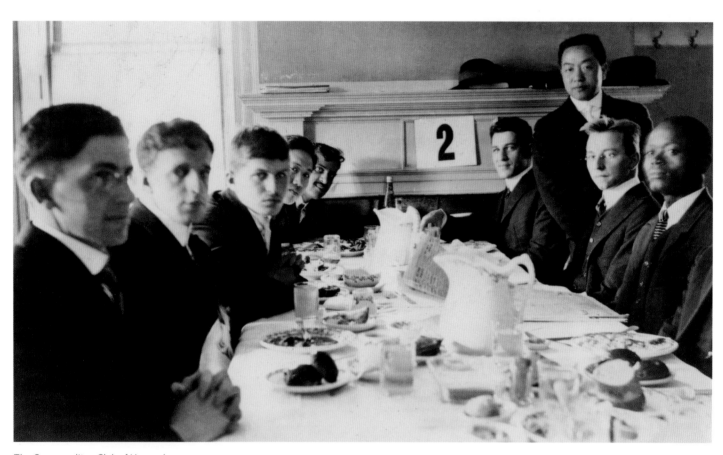

The Cosmopolitan Club of Harvard, 1914

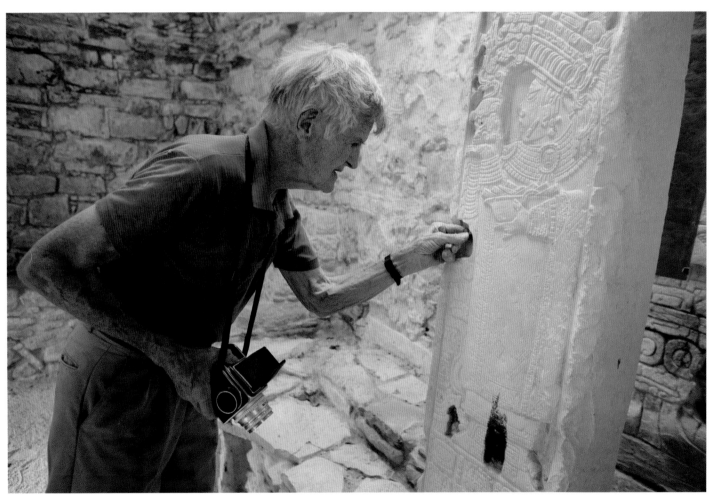

Exploring Mayan ruins in Mexico, 2007

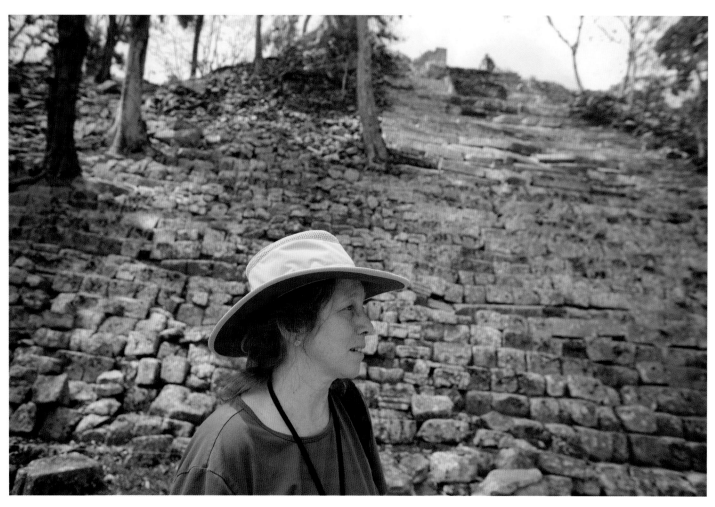

Exploring Mayan ruins in Honduras, 2007

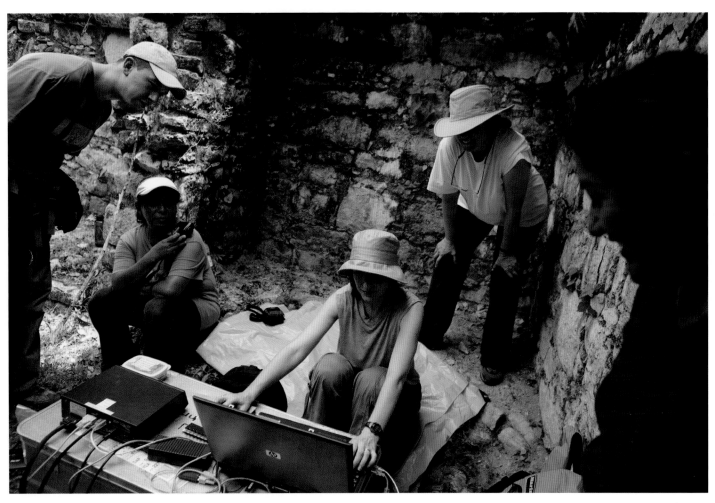

Scanning a monument in Mexico, 2007

Preserving the past in Mexico, 2007

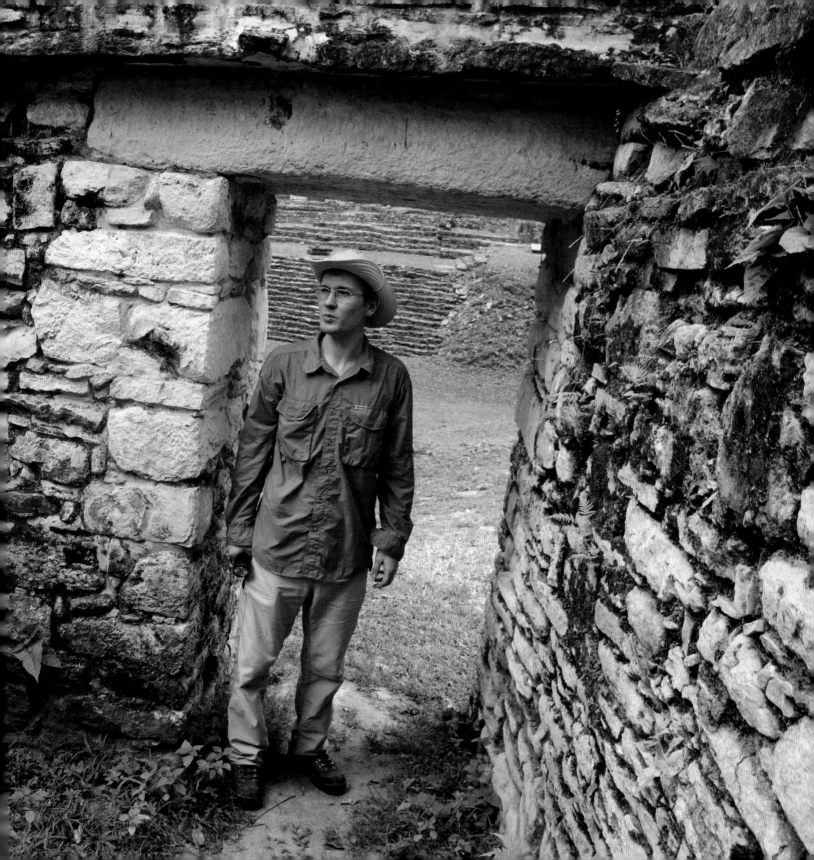

VI

i
feel that i cleverly am being altered that i slightly am becoming
something a little different, in fact
myself
Hereupon helpless i utter lilac shrieks and scarlet bellowings.

e. e. cummings, A.B. '15, A.M. '16,
from "my mind is"

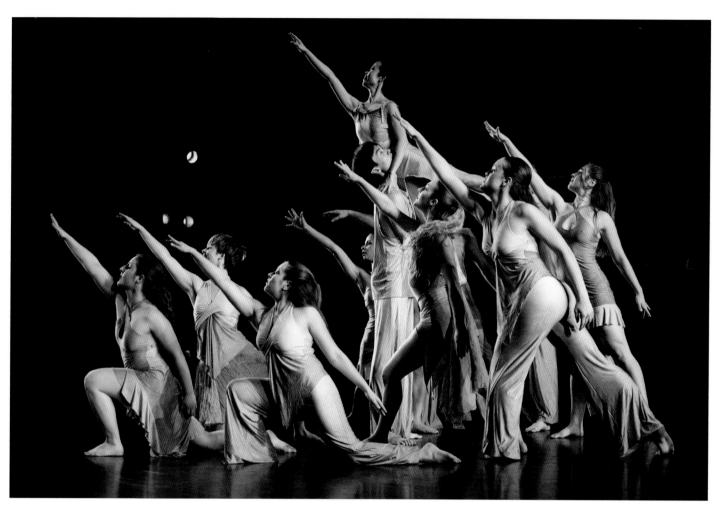

Contemporary Dance Ensemble, 2007

The arts teach us how to imagine the new, how to turn fresh ideas into reality. An institution that values creative thinking puts experience with the arts on par with the study of the sciences and the humanities. The arts abound at Harvard, home to the American Repertory Theater, the Harvard Film Archive, vast museum collections that include the ancient and the modern, more than one hundred undergraduate student art organizations, and instrumental and choral groups. Harvard has been called a place where dreams are born, and through the arts the institution encourages connections between the sciences, technology, and the humanities that push the boundaries of knowledge. Whether they are painting from nature, collaborating on a concerto, or staging the latest production of the longest continually performing opera company in New England, student artists at Harvard are shaping dreams as yet unimagined.

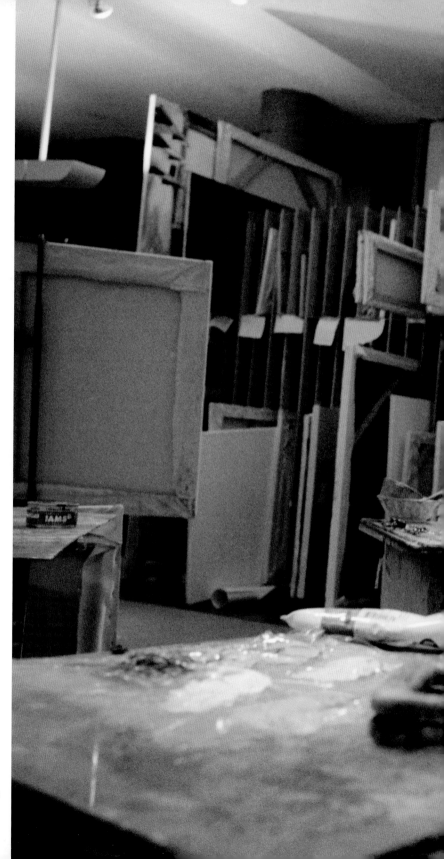

Painting in the Carpenter Center, 2002

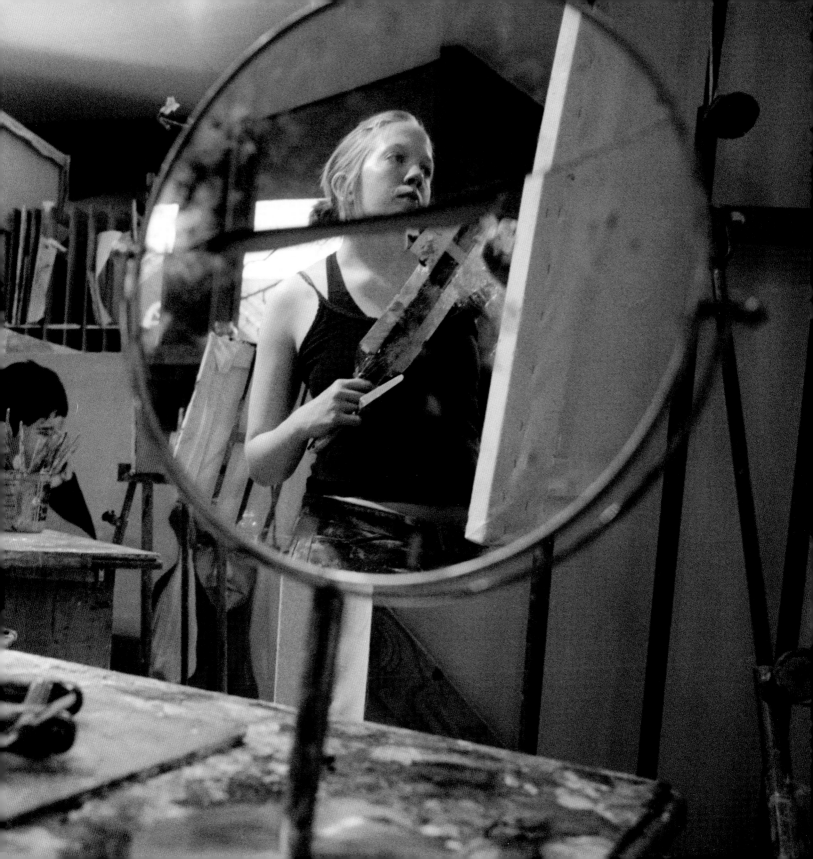

Choral conducting in Paine Hall, 2006

163

Art class, ca. 1962

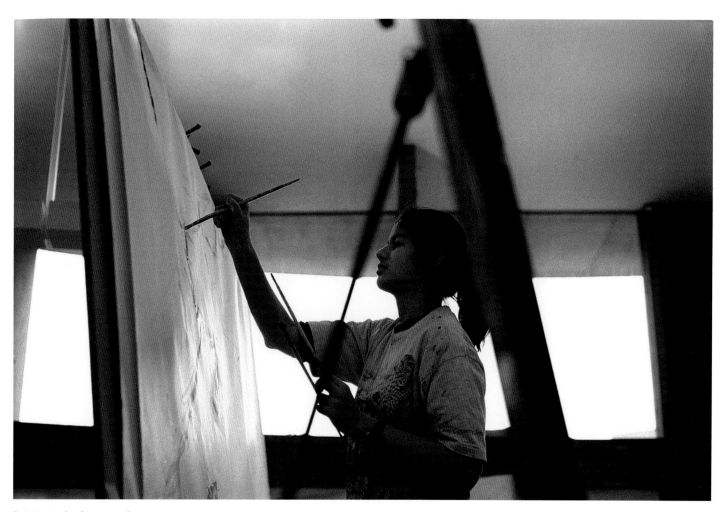

Painting in the Carpenter Center, 2003

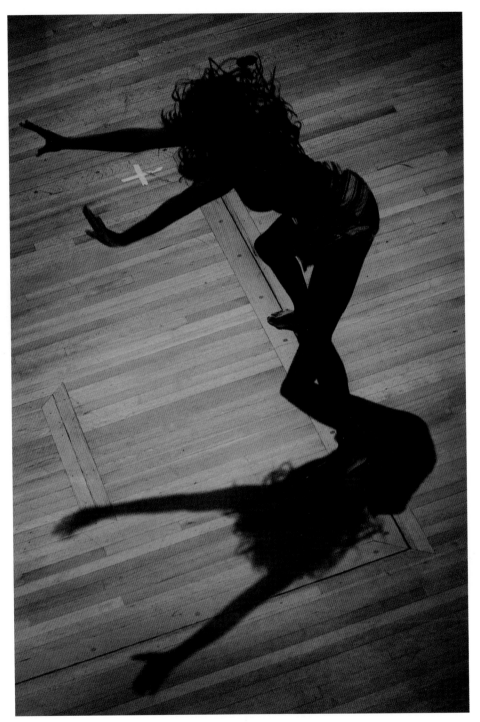

Pan African Dance and Music Ensemble performs in Sanders Theatre, 2009

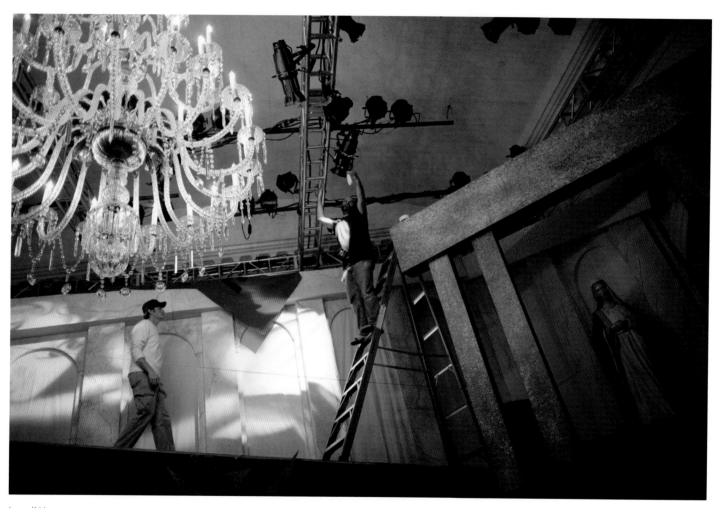

Lowell House opera, 2010

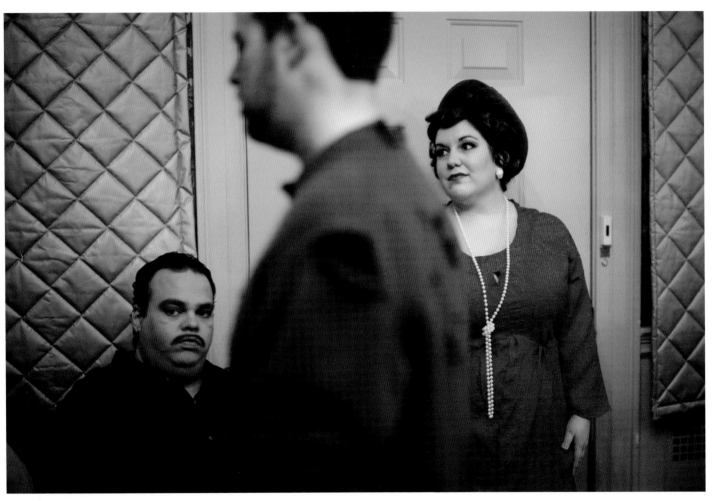

Lowell House opera, 2010

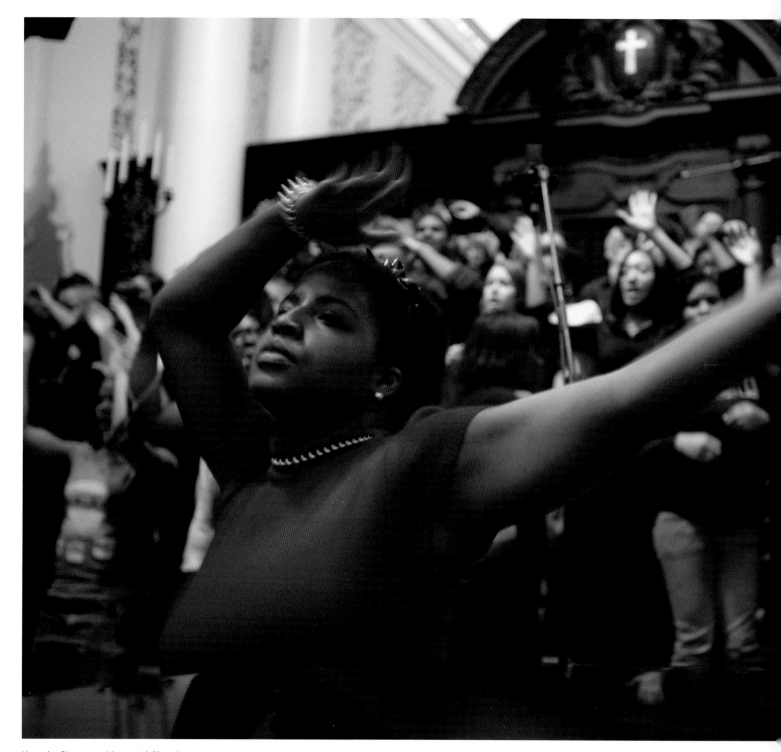

Kuumba Singers in Memorial Church, 2009

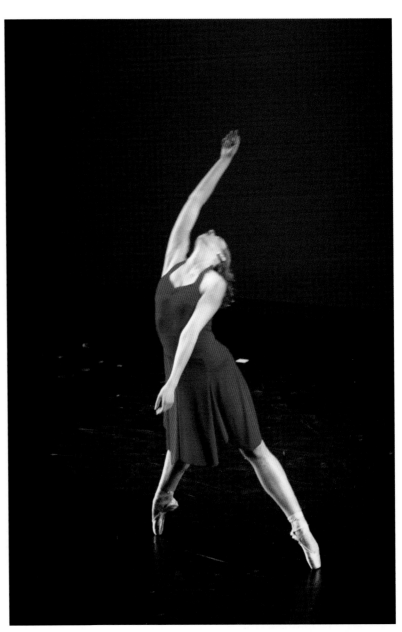

Dance, 2005 169

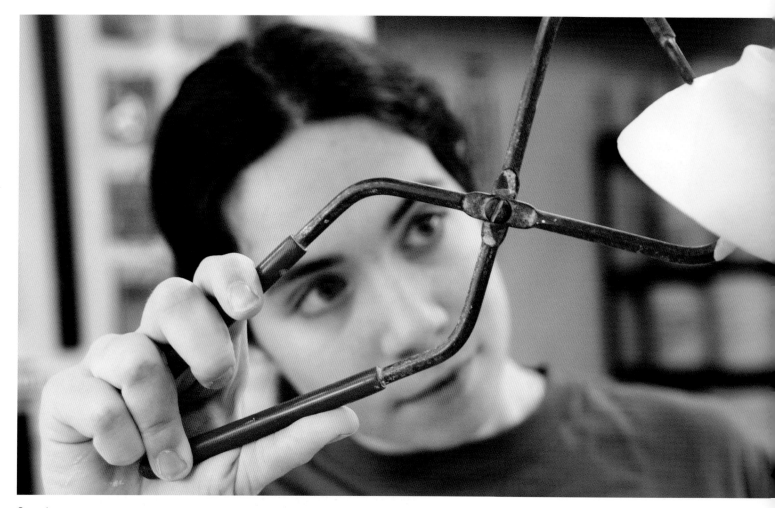

Ceramics, 2009

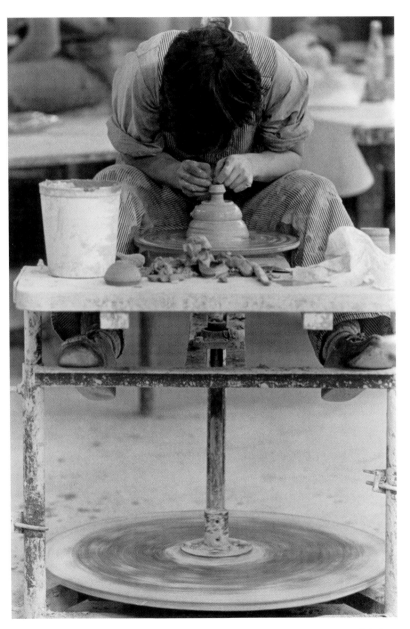

Art class

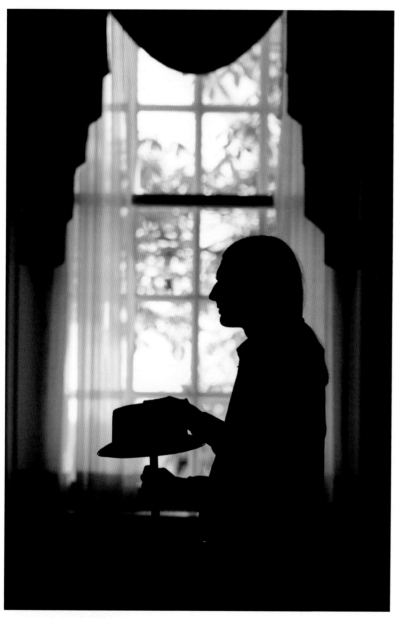

172 Musical theater in Dudley House, 2009

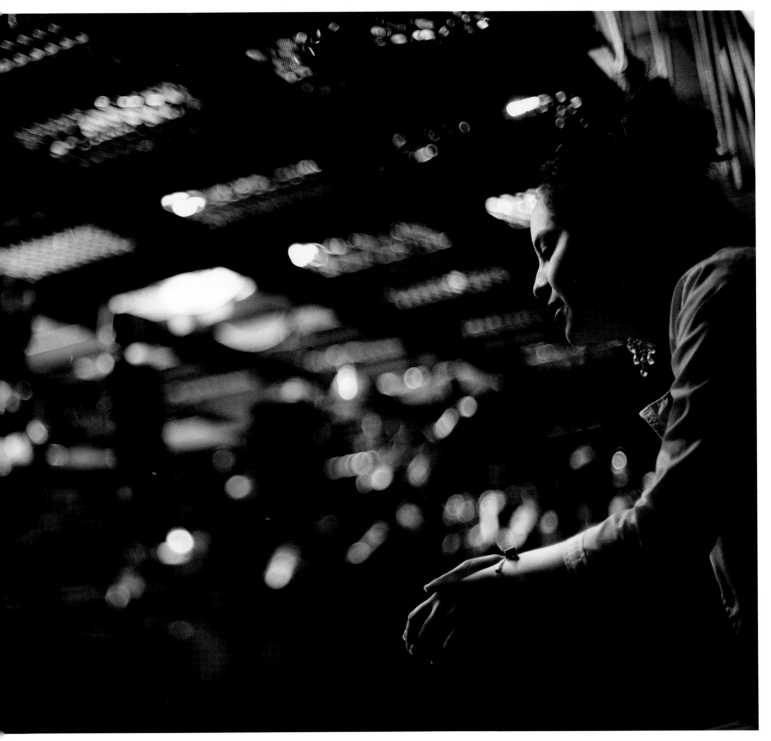

Directing at the Loeb Experimental Theater, 2009

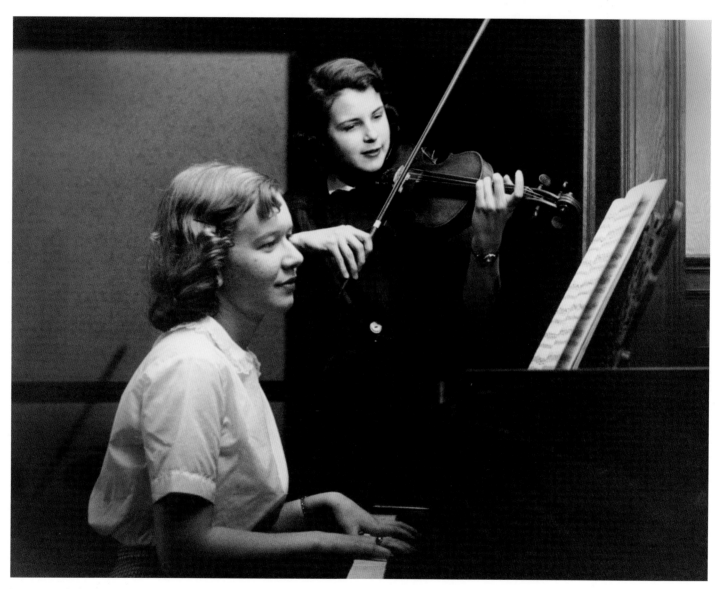

Music at Radcliffe College, ca. 1950

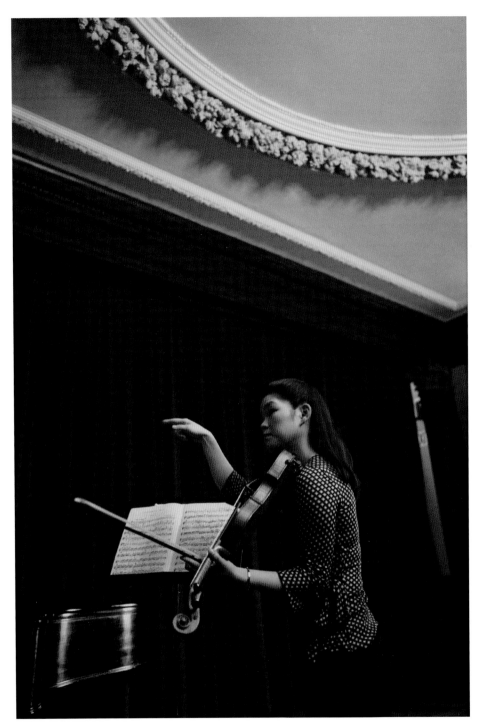

Learning from Performers in Winthrop House, 2004

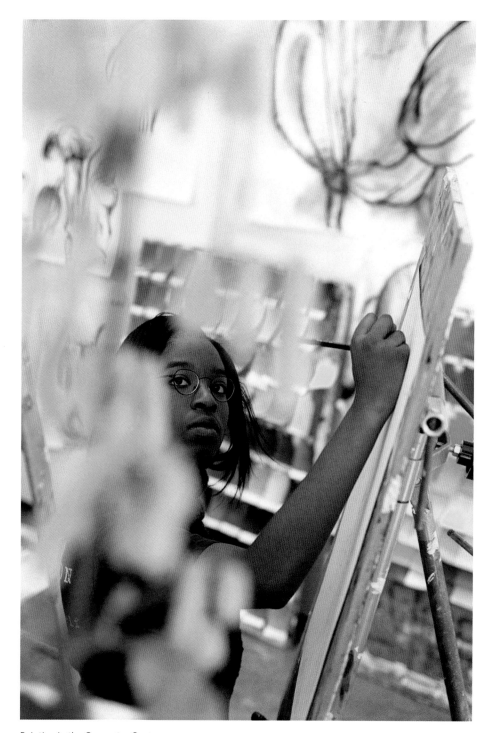

Painting in the Carpenter Center, 2004

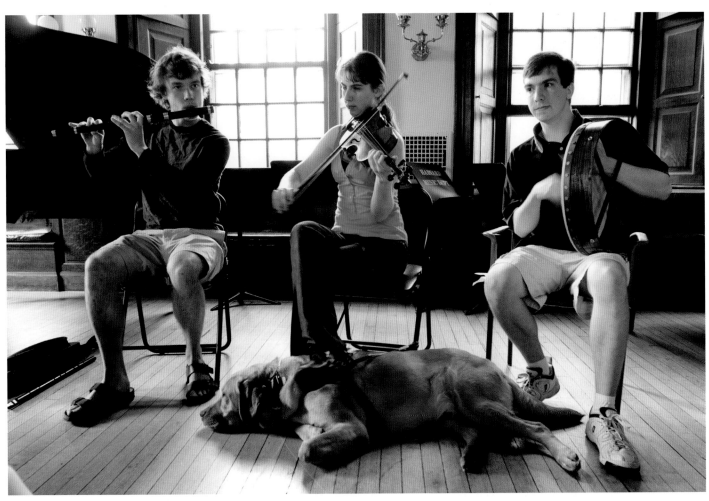

Traditional Irish dance music, 2009

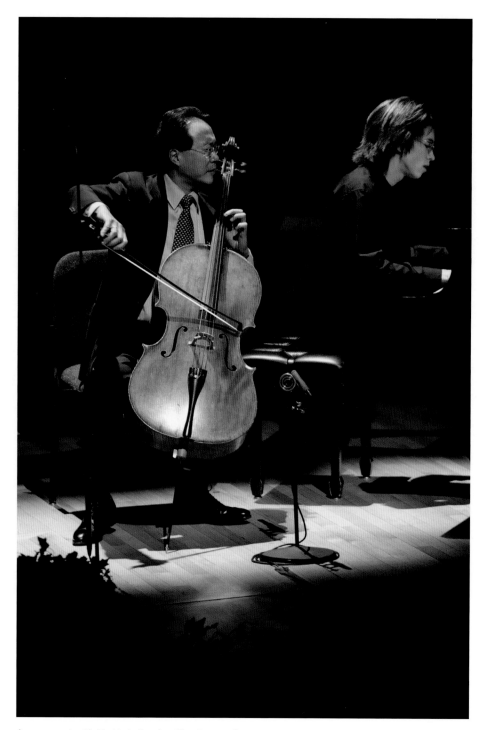

Accompanying Yo-Yo Ma in Sanders Theatre, 2008

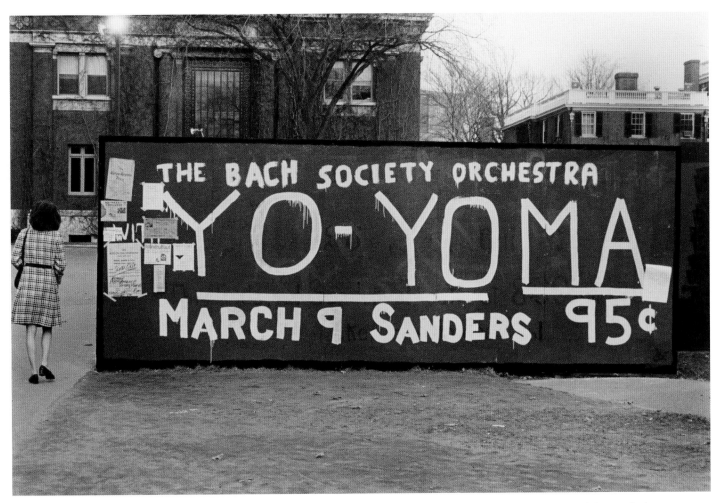

Advertisement for the Bach Society Orchestra, ca. 1970

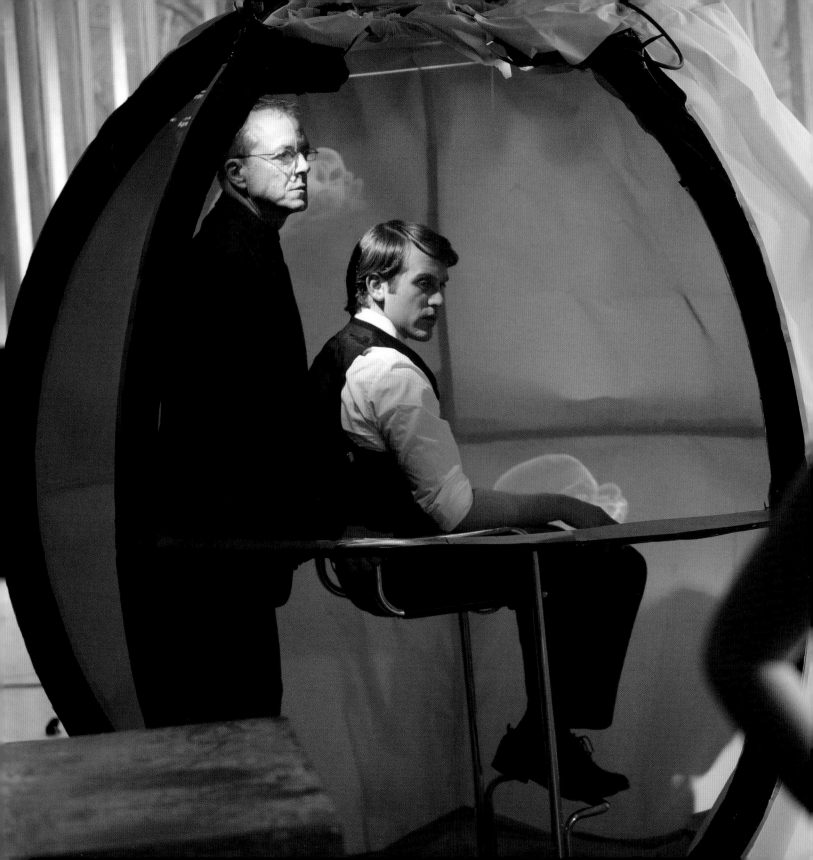

181

Film production, 2010

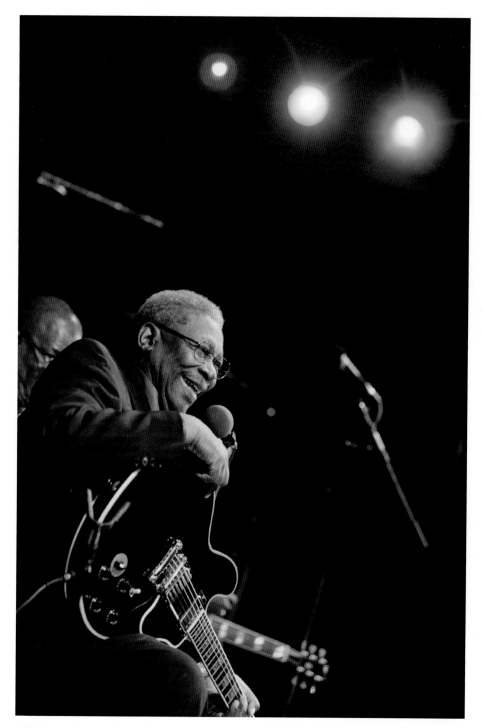

B. B. King performs at Harvard Extension School, 2004

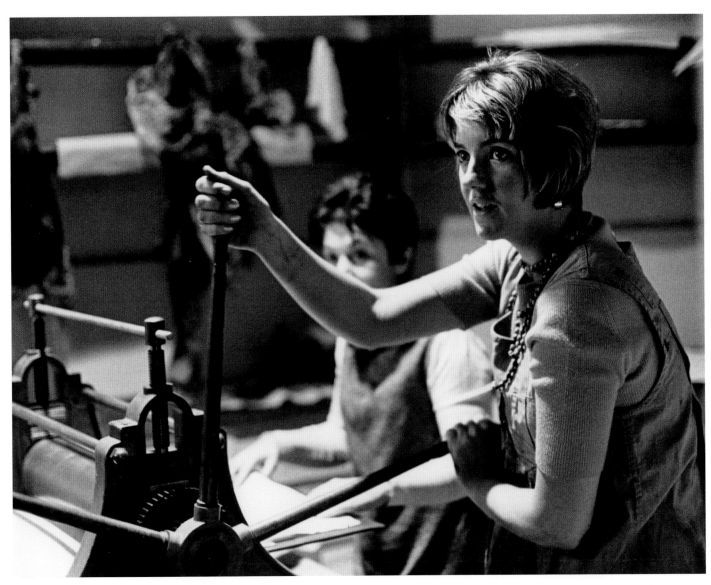

Art class, ca. 1972

André Previn leads a master class in Kirkland House, 2008

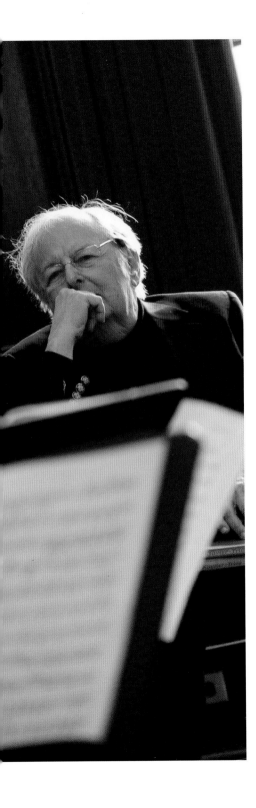

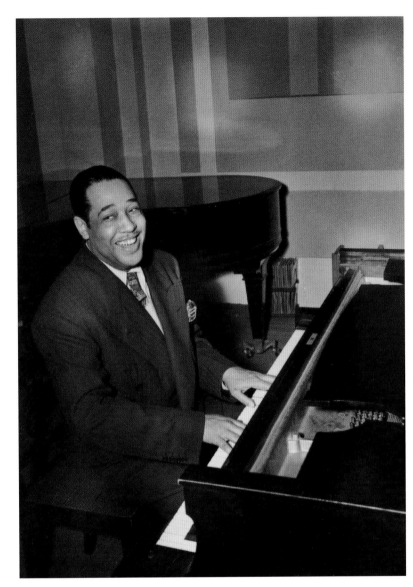

Duke Ellington in Paine Hall, 1944

VII

There is nowhere to hide when the ball's
spotlight swivels your way,
and the chatter around you falls still,
and the mothers on the sidelines,
your own among them, hold their breaths

John Updike, A.B. '54, Litt. D. '92,
from "Baseball"

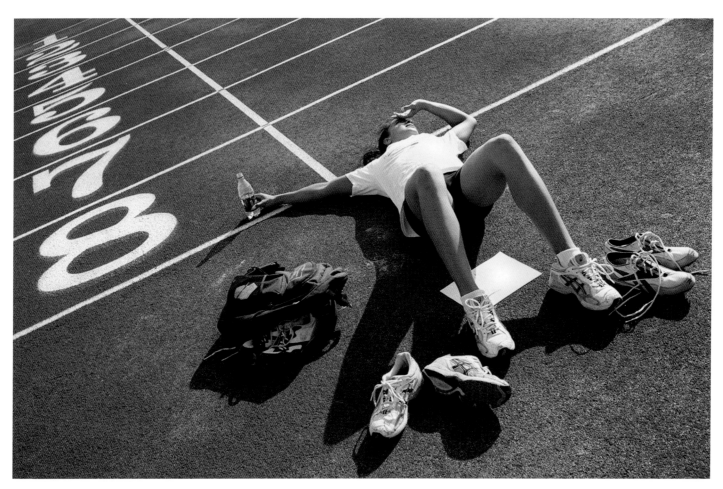

Women's track and field, 2001

In 1858, a pair of Harvard rowers gave their crewmates crimson scarves to wear so that regatta spectators could pick out the Harvard boat from the riverbank—and thus a tradition was born. After one of those rowers, Charles W. Eliot, retired as president of the University in 1909, the Corporation voted to make the color of Eliot's scarves the official hue of Harvard. Today, the prominence of athletics on the Harvard campus is as easy to see as those crimson scarves flying behind the straining rowers. The University regularly fields more Division I NCAA teams than any other school, consistently producing collegiate champions and Olympic competitors, as well as its share of professional athletes. "Athletics for All" is a College motto: In any given year, some three thousand young men and women engage in more than three dozen club sports, building strong connections through rigorous teamwork, assimilating lessons through physical exertion that they can build upon after life at the College.

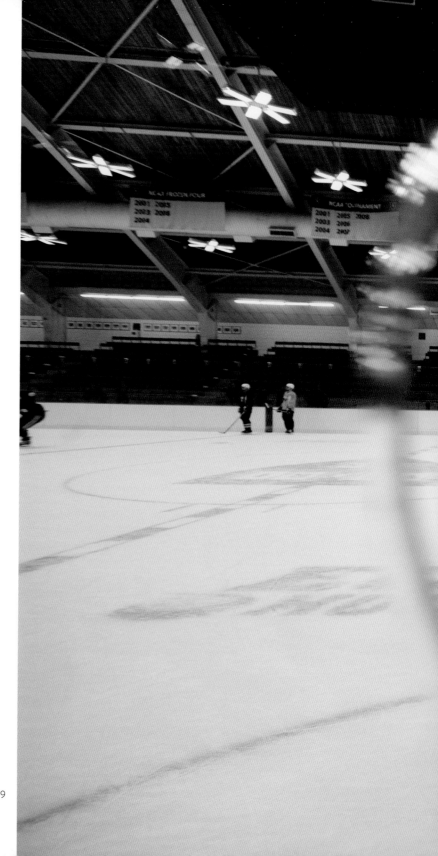

Men's hockey, 2009

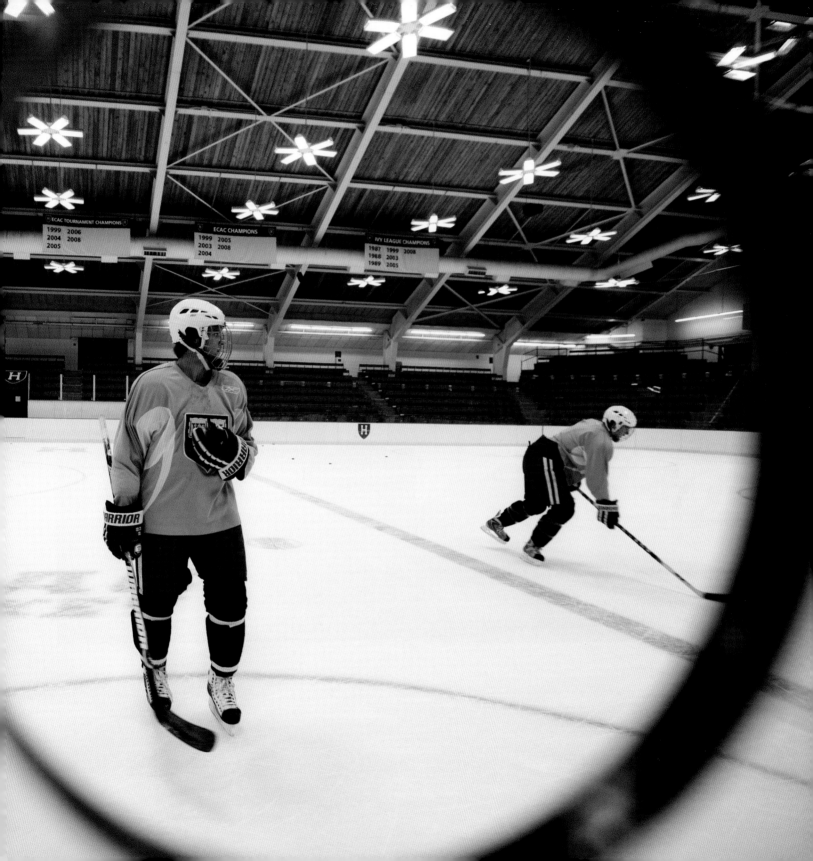

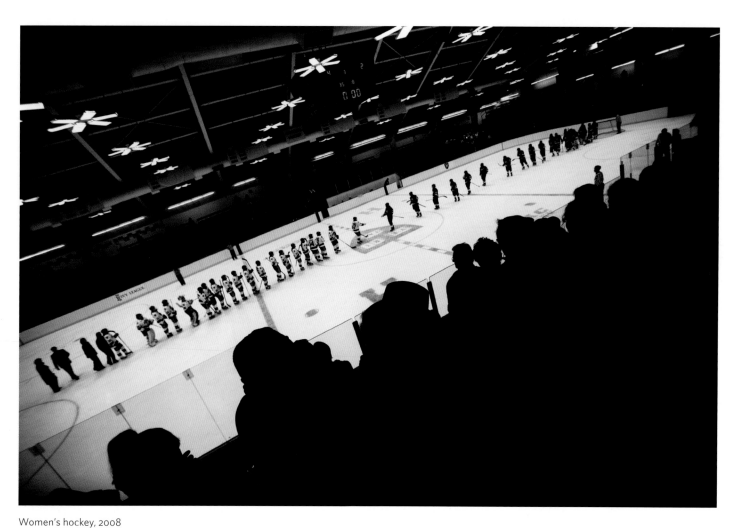

Women's hockey, 2008

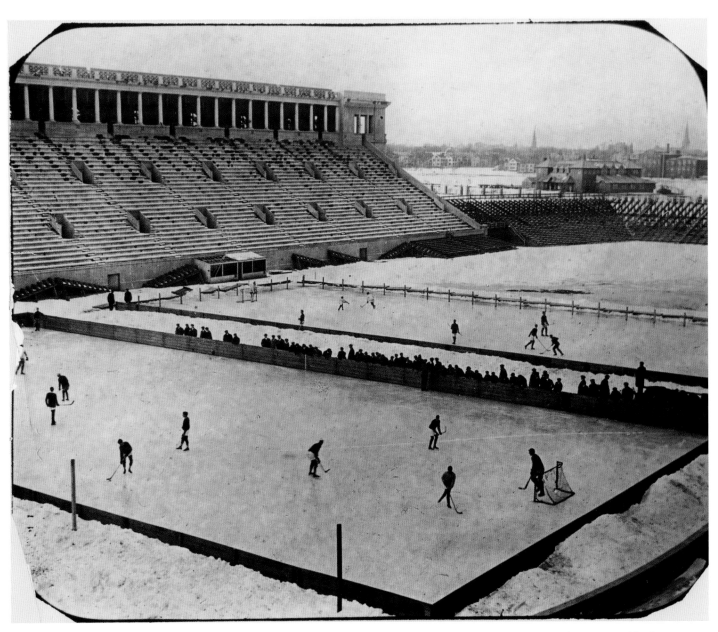

Hockey in Harvard Stadium, ca. 1920 193

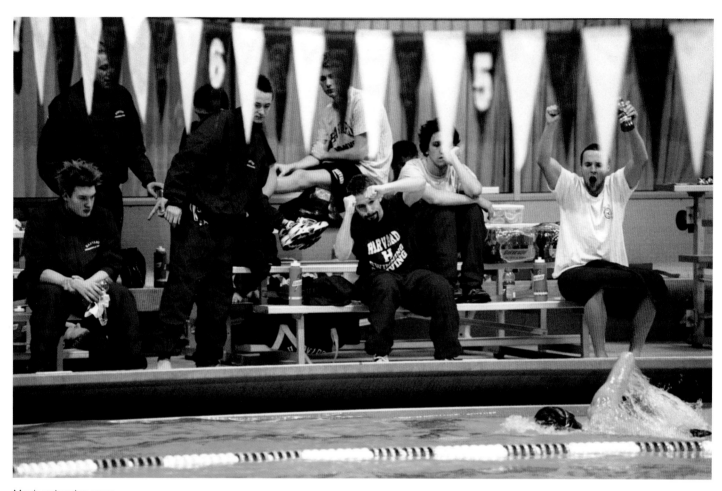

Men's swimming, 2003

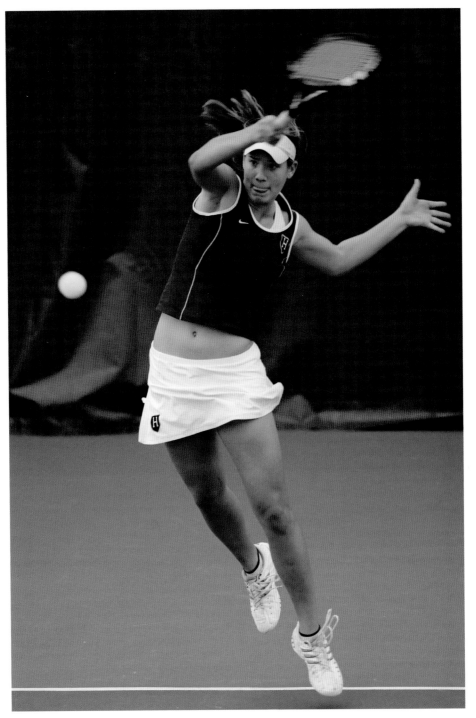

Women's tennis, 2007

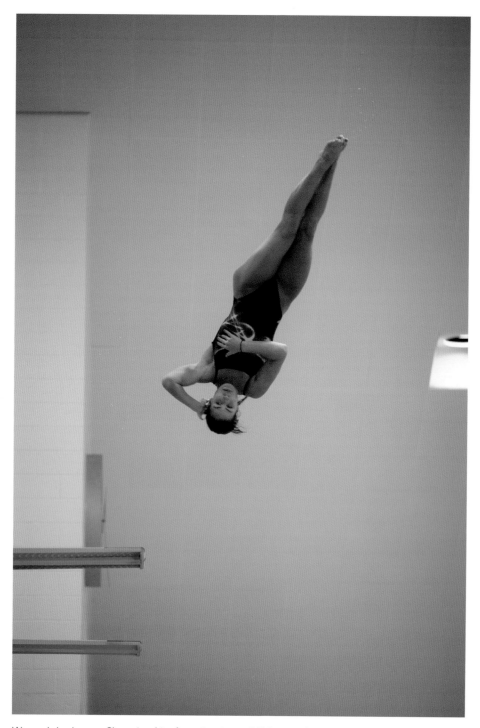

Women's Ivy League Championships for swimming and diving, 2006

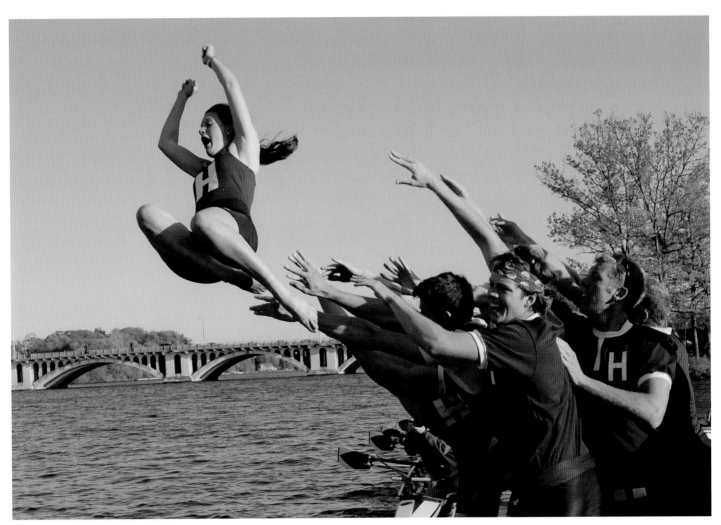

Winning the Rowe Cup, 2007

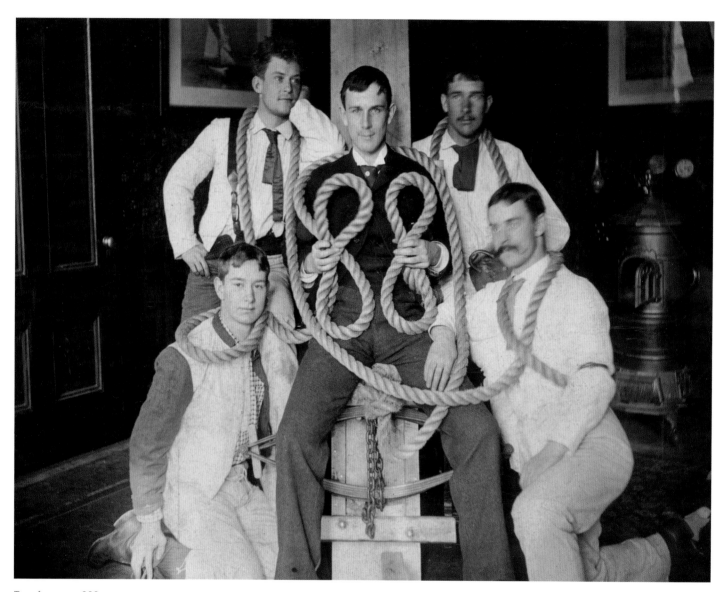

Tug of war, ca. 1888

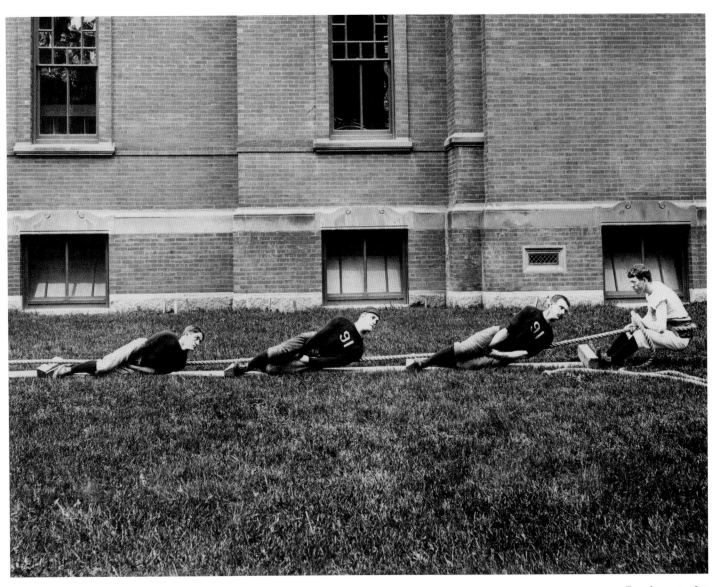

Tug of war, ca. 1891

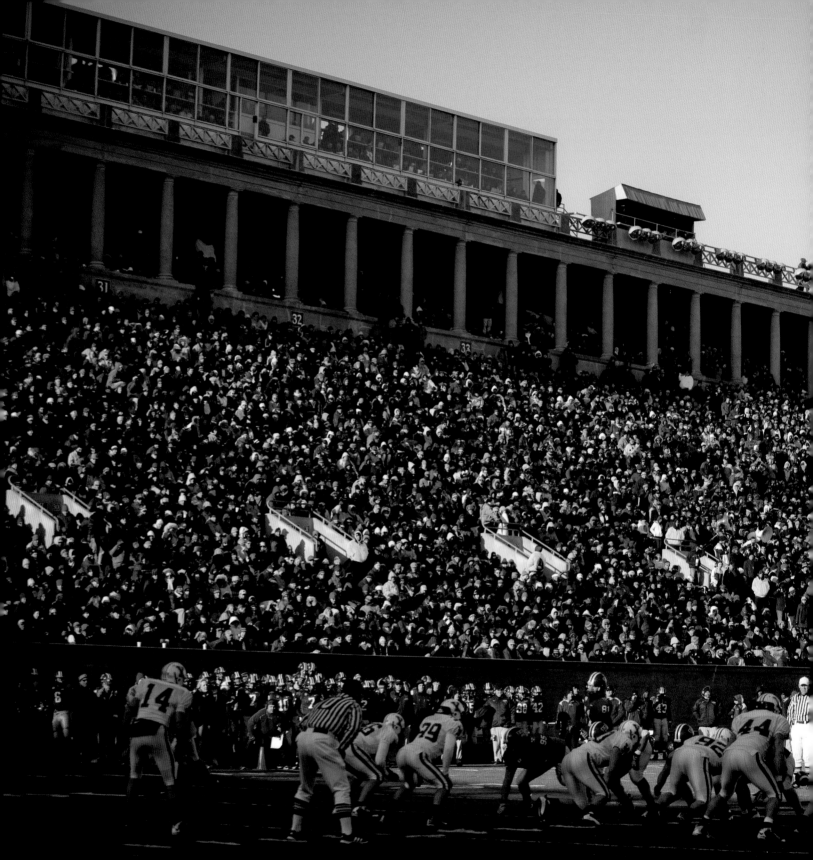

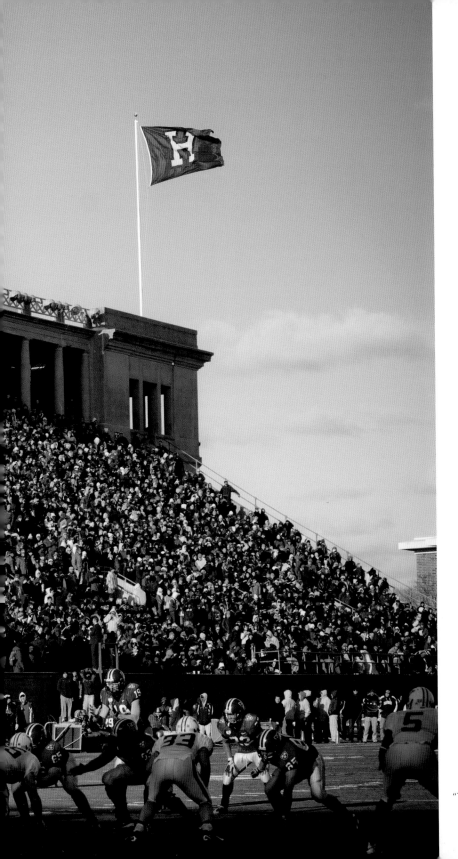

201

"The Game," 125th playing, Harvard vs. Yale at Harvard Stadium, 2008

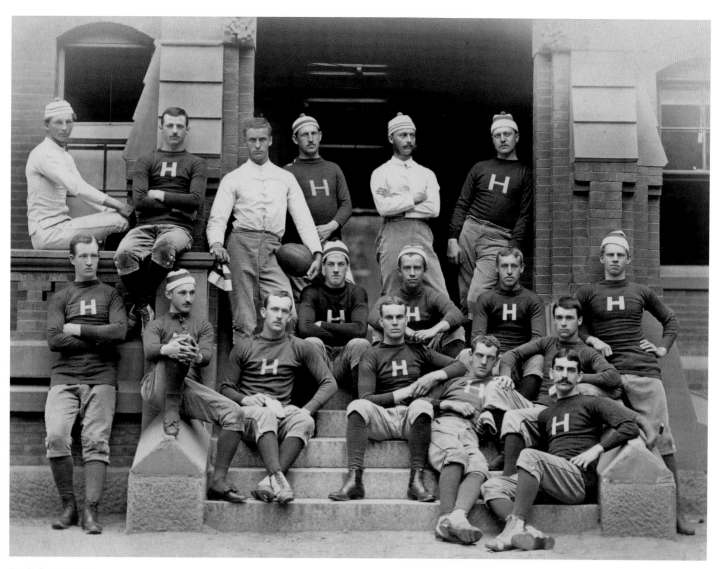

Football team, 1878

Cheerleading at "the Game," 2008

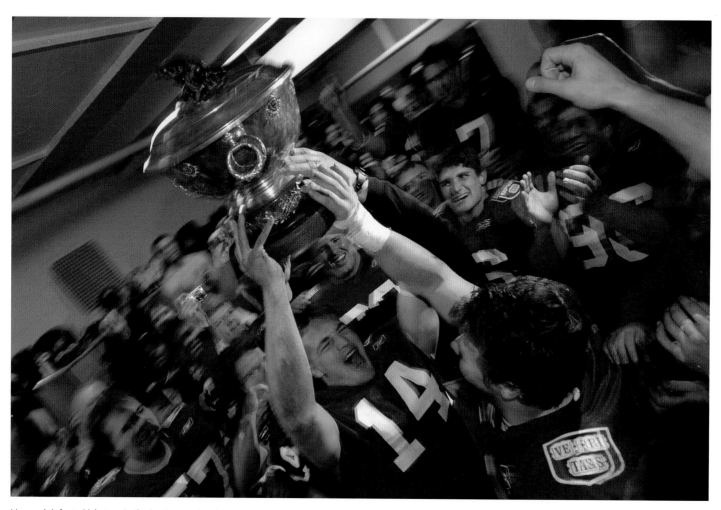

Harvard defeats Yale to win the Ivy League trophy, 2004

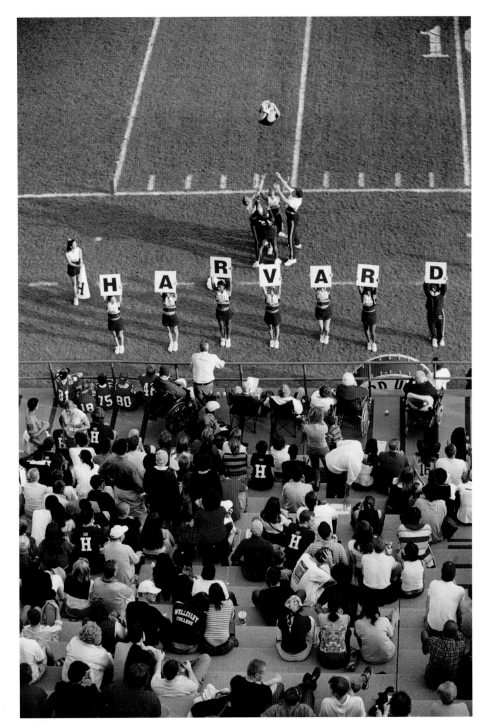

Cheerleading, 2003

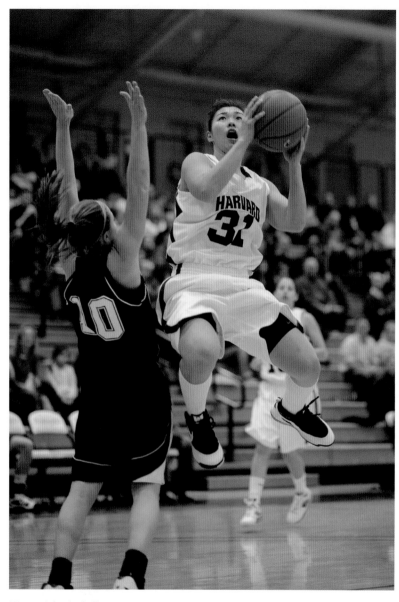

Women's basketball, 2009

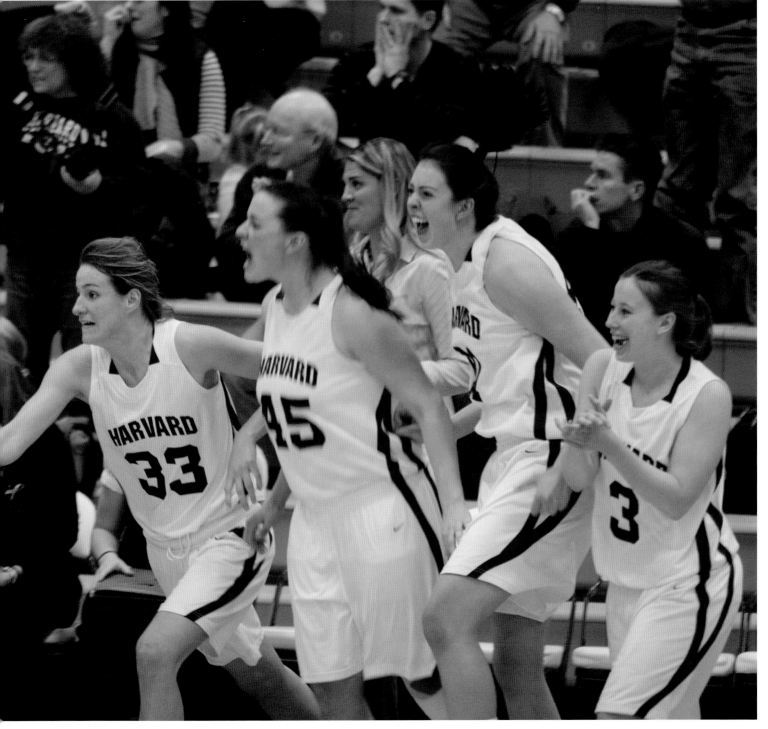

Women's basketball, 2009

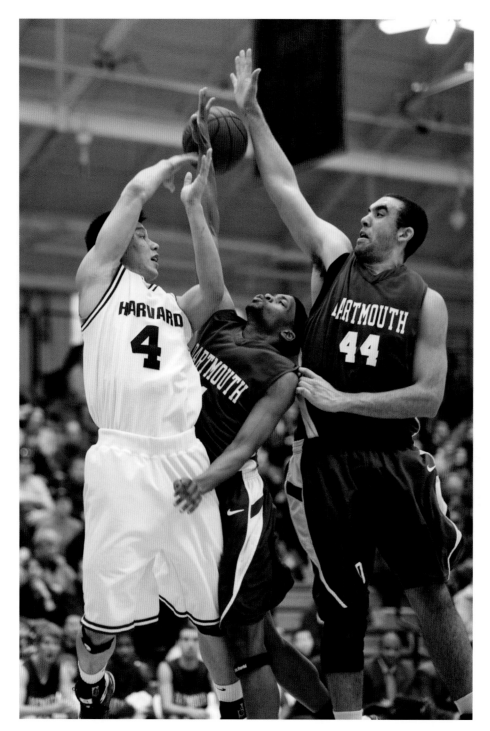

Men's basketball, 2010

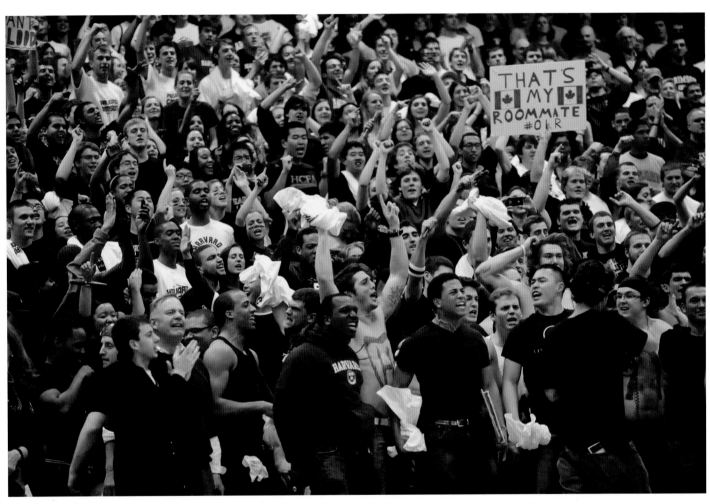

Cheering on the Crimson as they clinch their first-ever Ivy League Basketball title, 2011

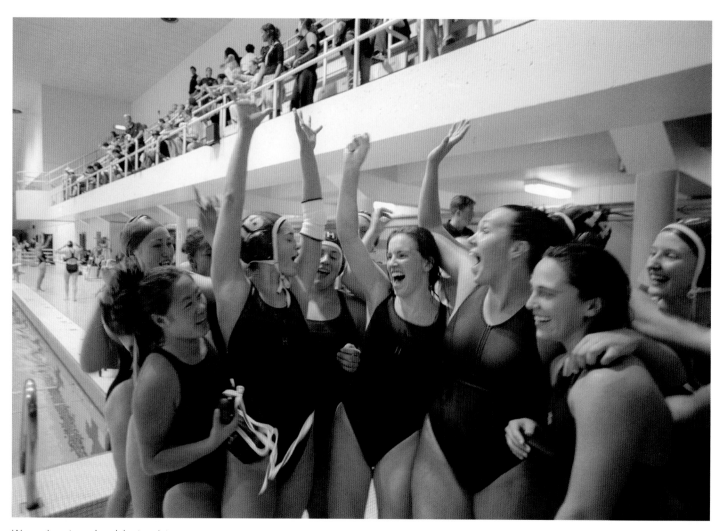

Women's water polo celebrates victory, 2003

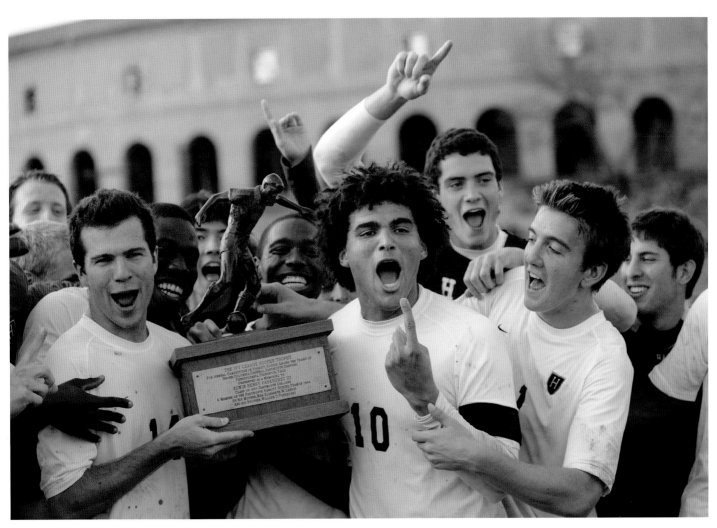

Men's soccer captures the Ivy League title, 2009

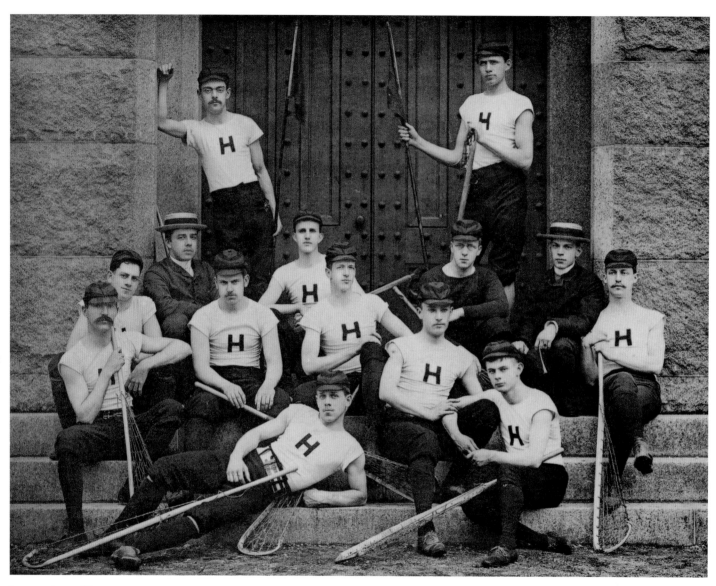

Lacrosse team, 1885

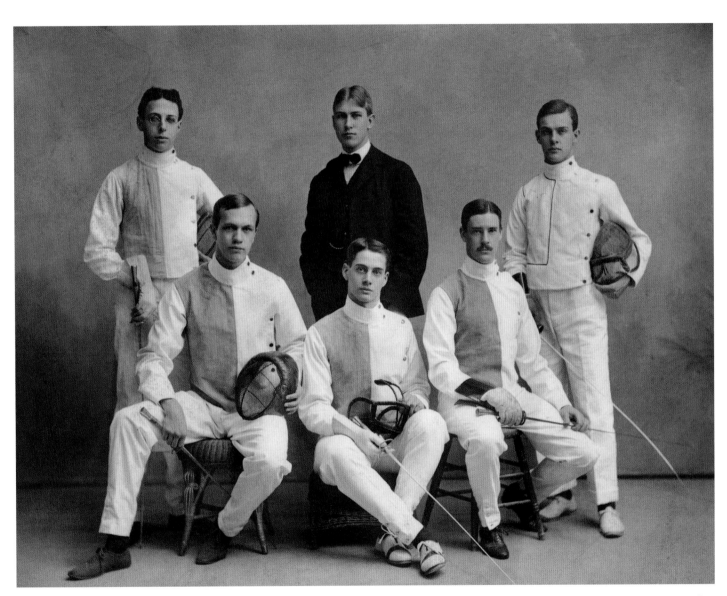

Fencing, ca. 1890

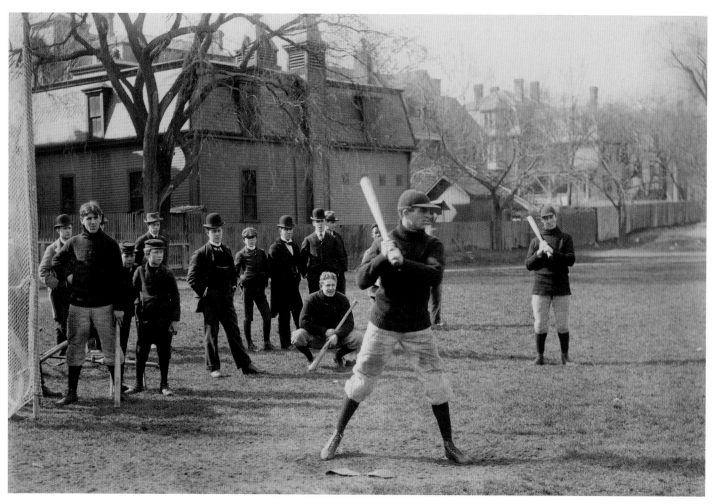

Baseball, 1898

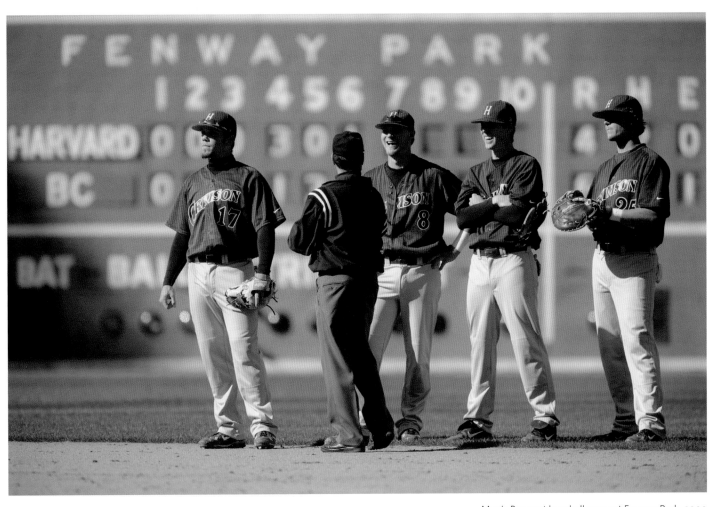

Men's Beanpot baseball game at Fenway Park, 2009

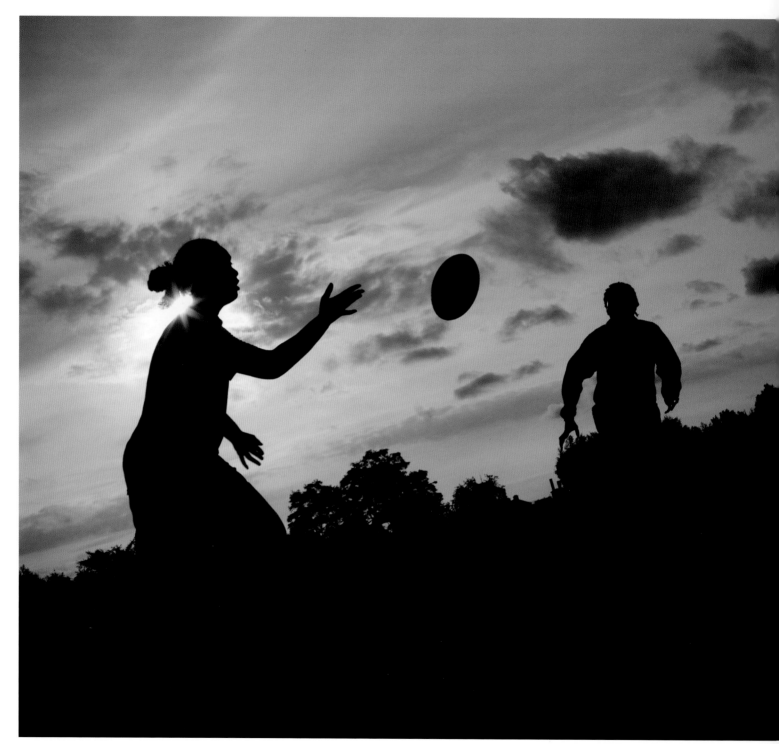

Women's rugby, 2006

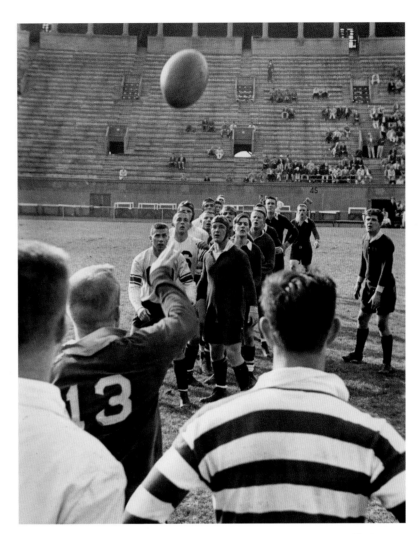

Rugby, 1957

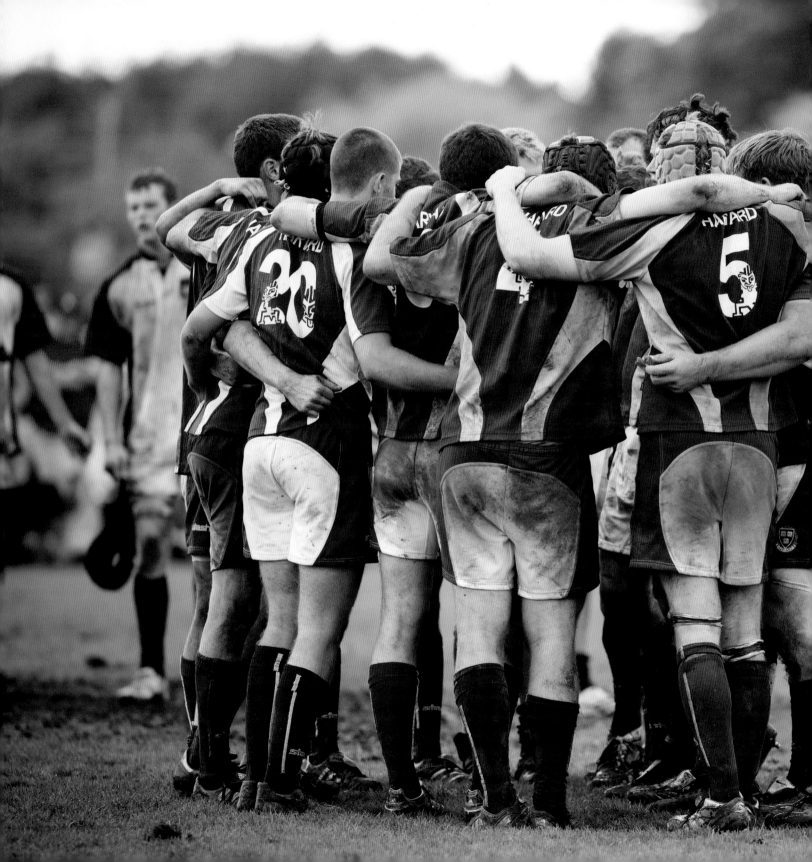

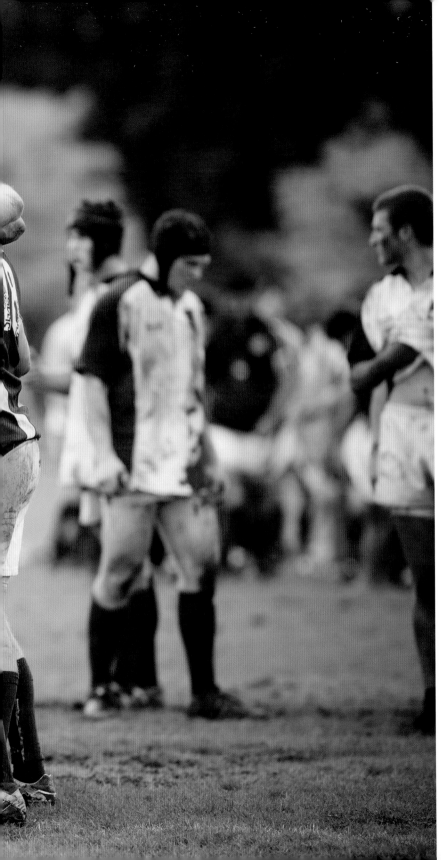

Men's rugby, 2007

VIII

Fair Harvard! we join in thy Jubilee throng,
And with blessings surrender thee o'er
By these festival rites, from the age that is past,
To the age that is waiting before.

Samuel Gilman, Class of 1811,
from "Fair Harvard"

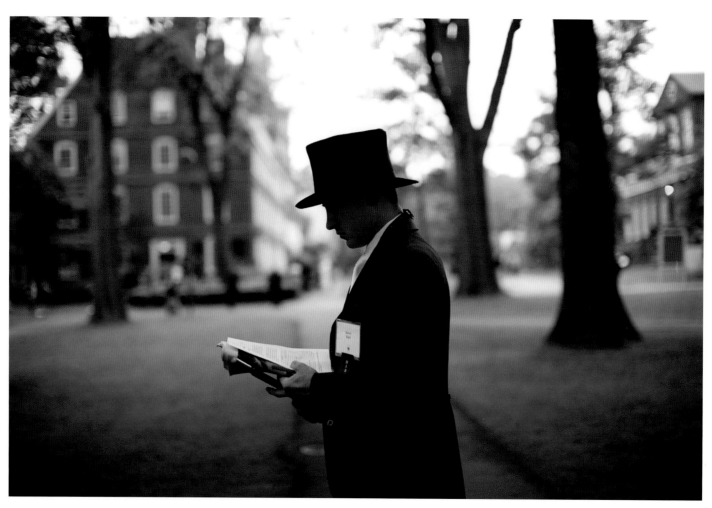

Marshal in Harvard Yard, 2010

W e shall not cease from exploration," one of Harvard's most accomplished alumni, T. S. Eliot, wrote in a stanza that seems to capture the spirit of the campus. The end of the academic journey is the beginning of a new phase of life for thousands of graduates, a moment appropriately marked with traditional pomp and spontaneous revelry. At Commencement, we celebrate not so much endings as beginnings, because at the end of all our exploring we arrive, as Eliot wrote, where we started, "and know the place for the first time." The graduating students returning to the Yard one more time on this day of ceremony are the same people who matriculated not so very long before. But profoundly changed by all that they have experienced in the intervening years, they see the world with new eyes.

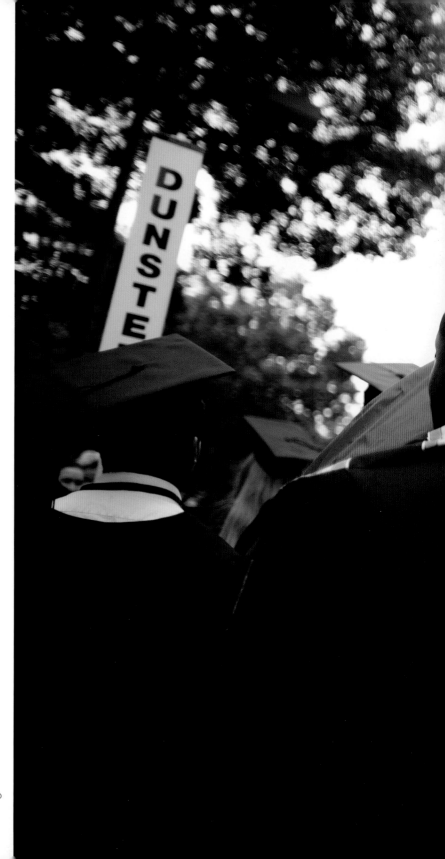

224

Processing past the steps of Widener Library, 2010

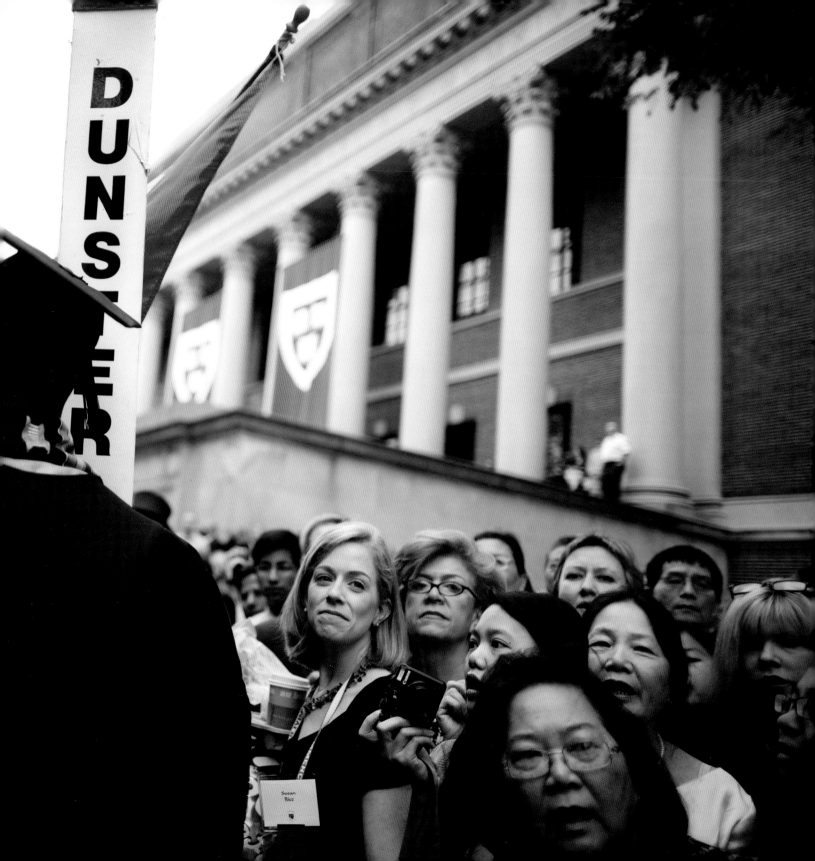

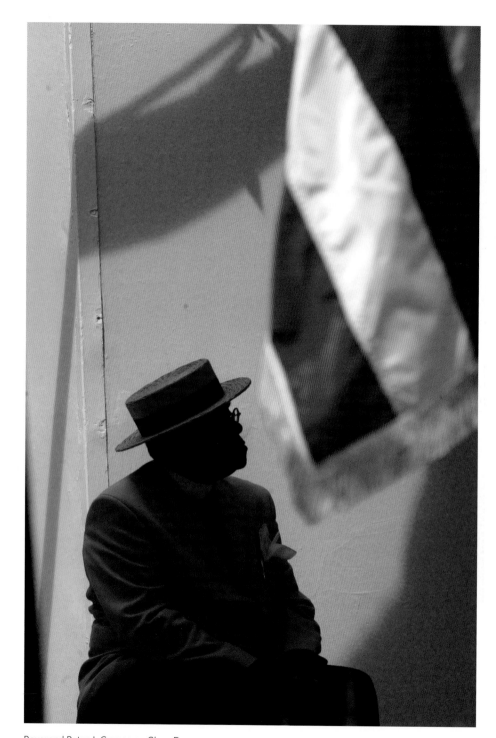

Reverend Peter J. Gomes on Class Day, 2004

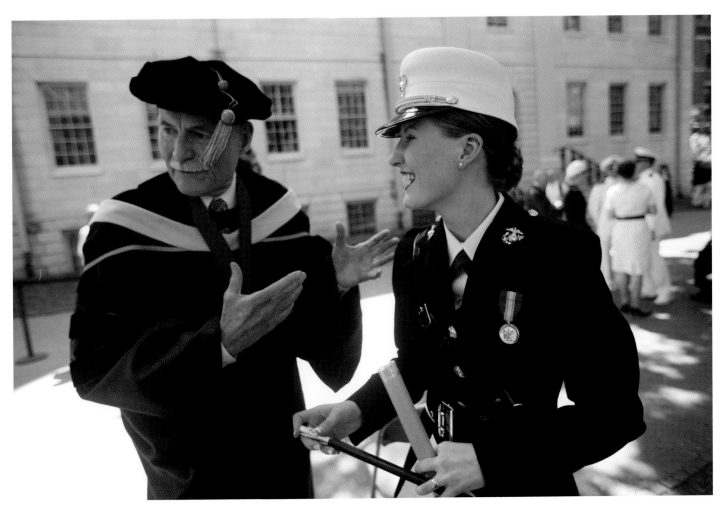

ROTC commissioning ceremony, 2010

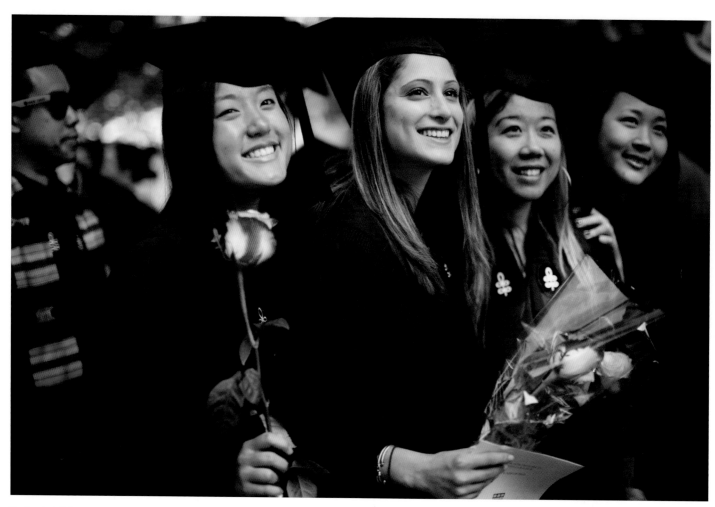

Posing for pictures, 2010

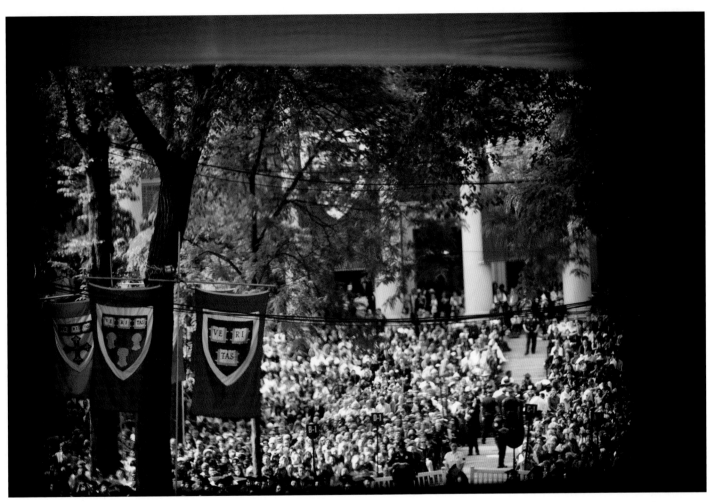

Tercentenary Theatre, 2010

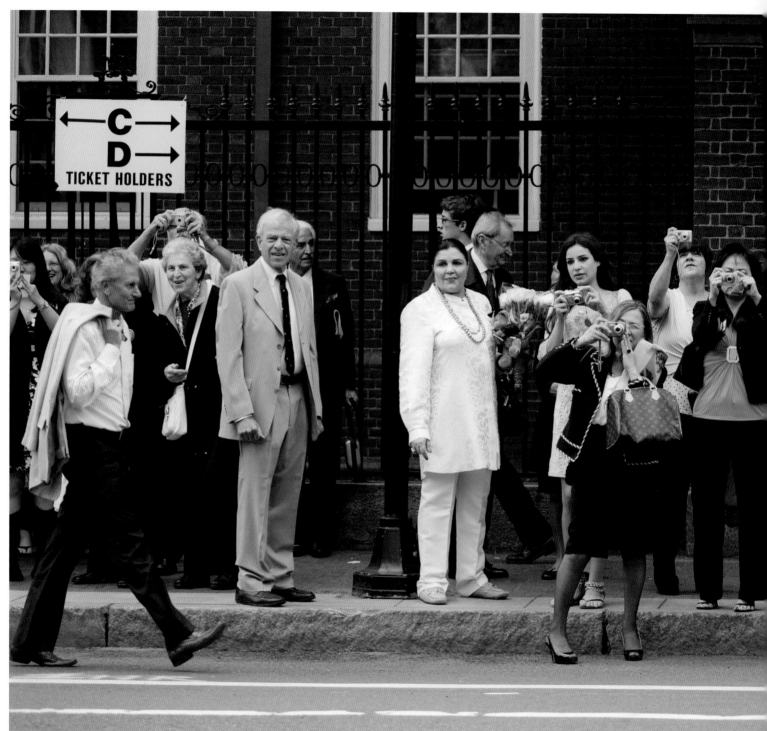

230

Massachusetts Avenue, 2010

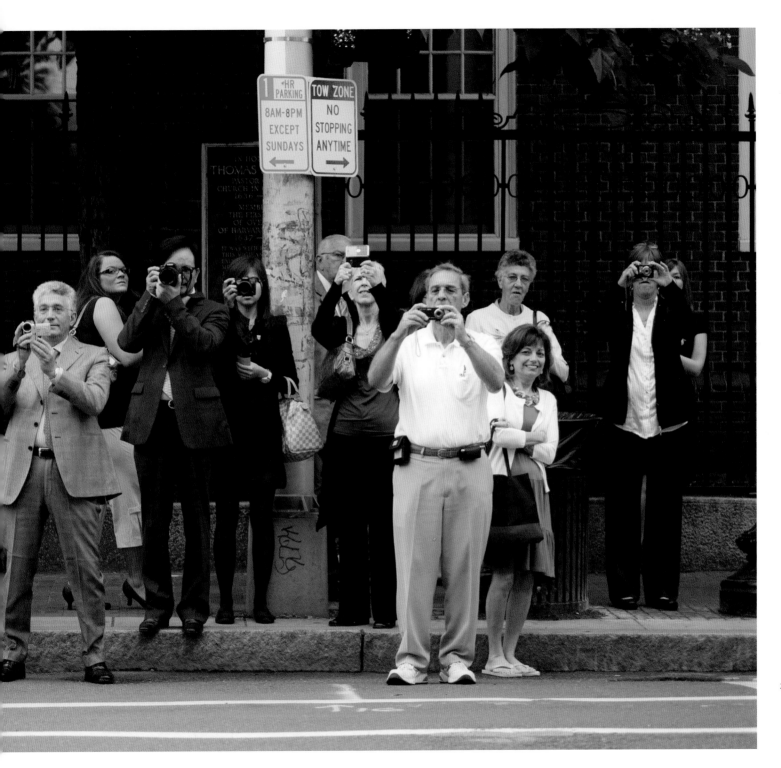

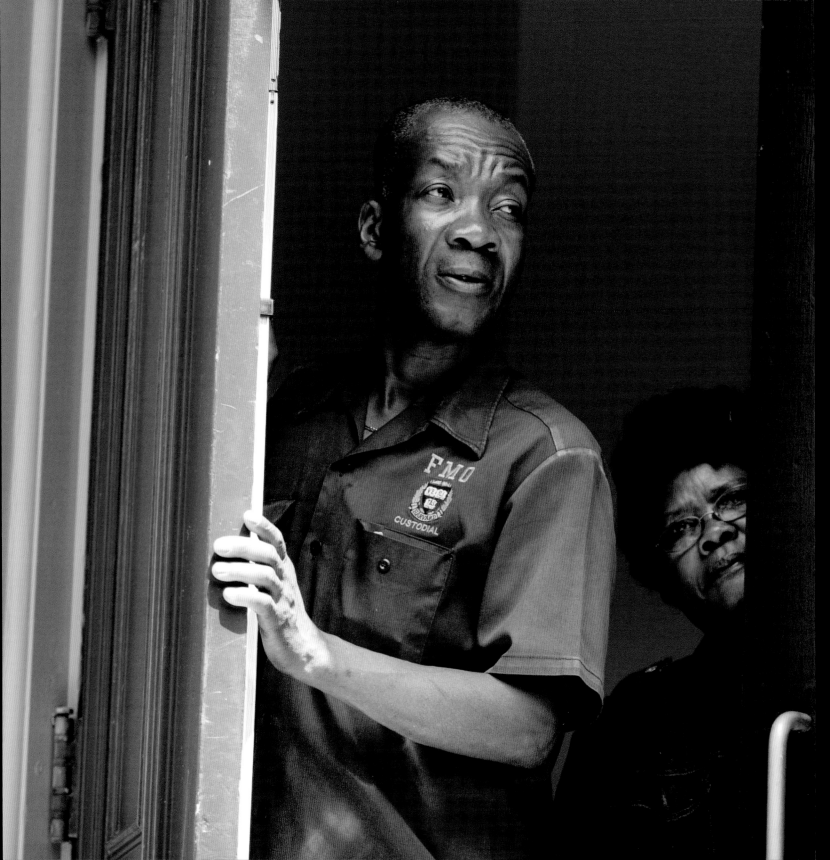

233

Watching the Baccalaureate Procession, 2009

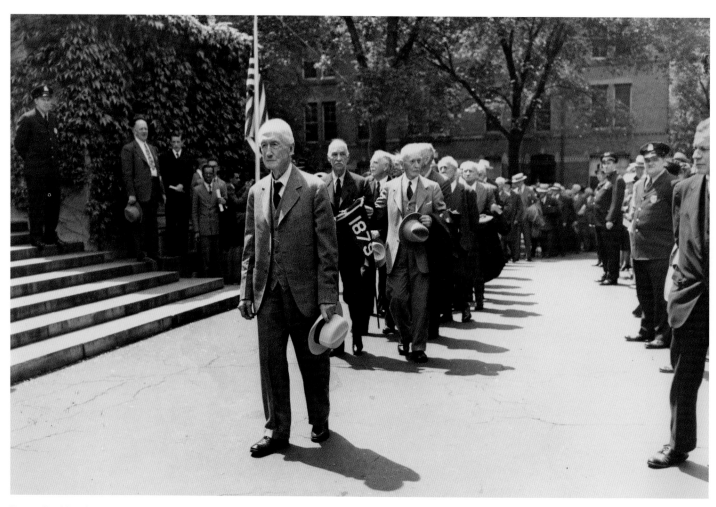

Harvard's oldest living graduate, Dr. Alfred Worchester, class of 1878, leads the Alumni Procession, 1947

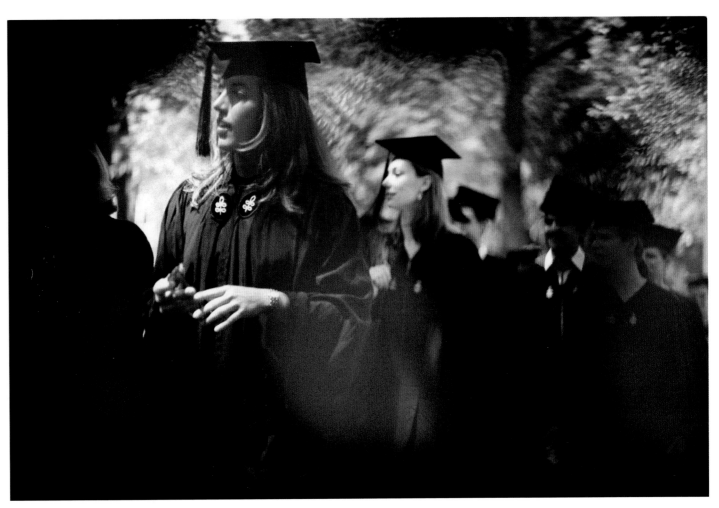

Baccalaureate Procession to Memorial Church, 2005

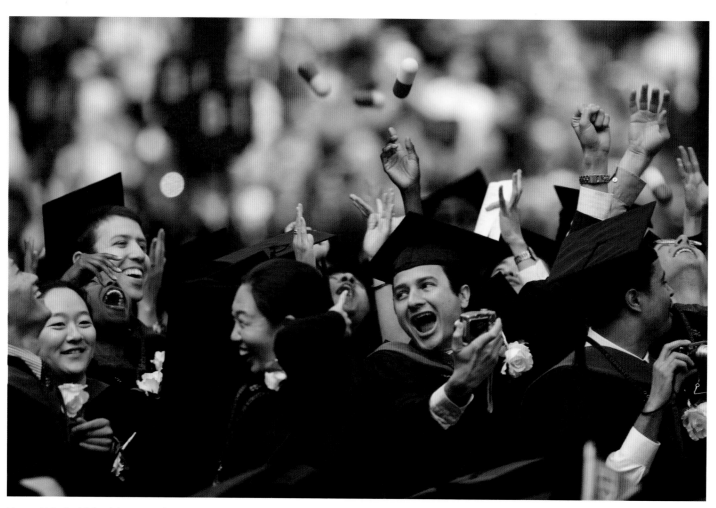

Harvard Medical School degree conferment, 2008

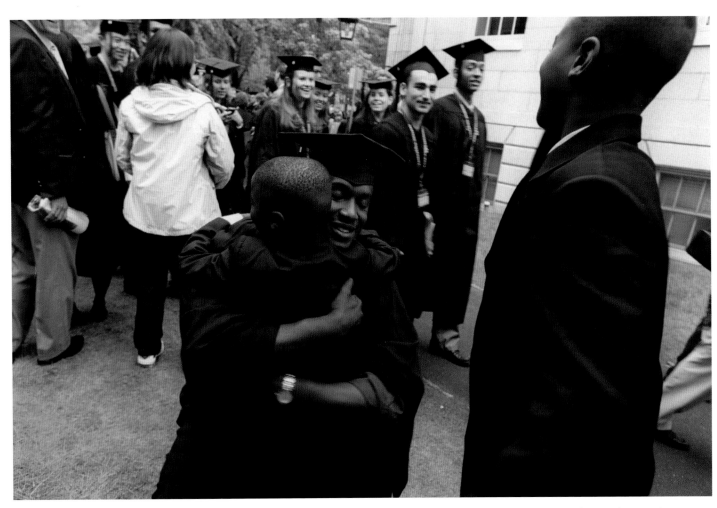

Congratulatory embrace, 2009

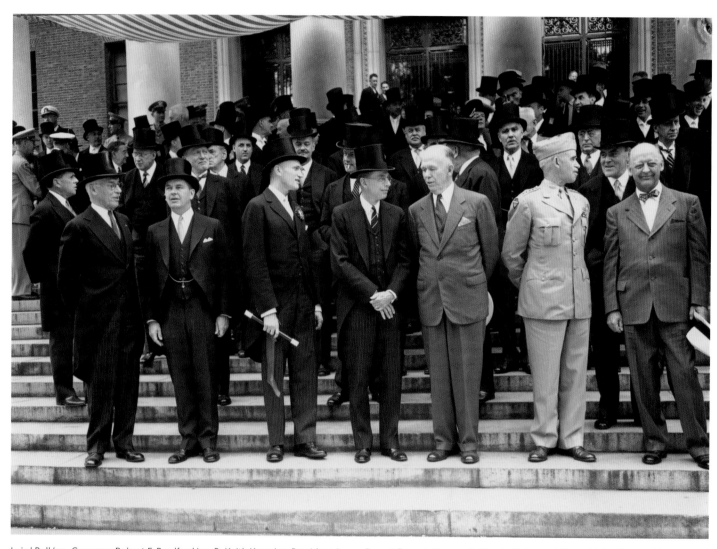

Laird Bell '04, Governor Robert F. Bradford '23, R. Keith Kane '22, President James Bryant Conant, George C. Marshall, General Omar N. Bradley, and former senator James W. Wadsworth on the steps of Widener Library, 1947

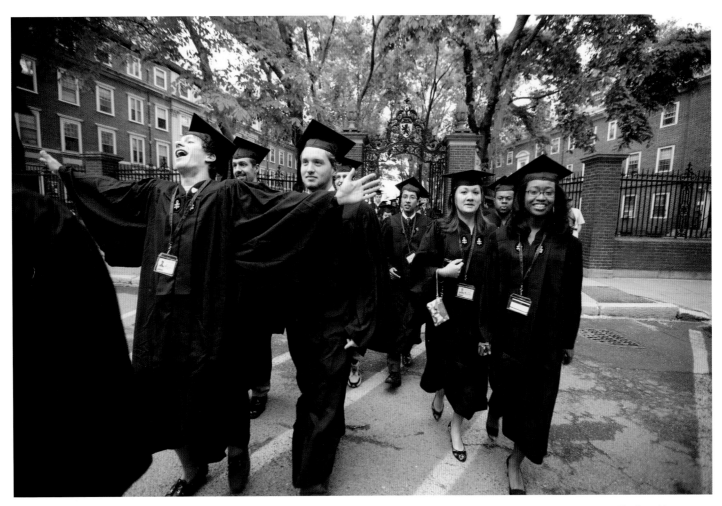

Winthrop House, 2010

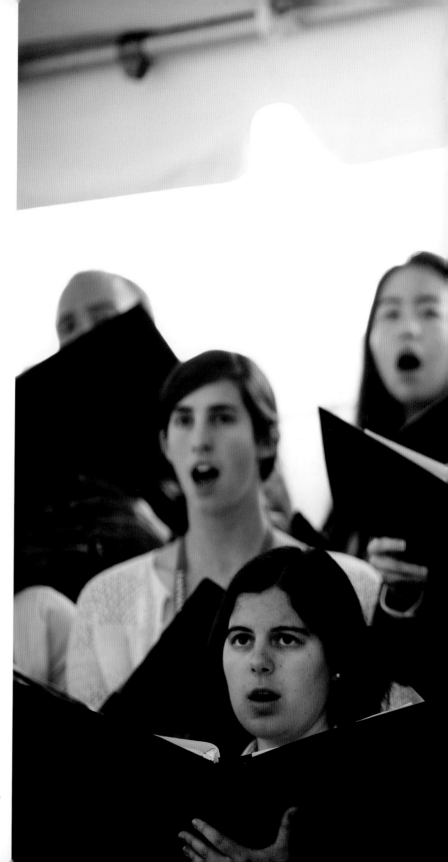

240

Morning Exercises choir accompaniment, 2010

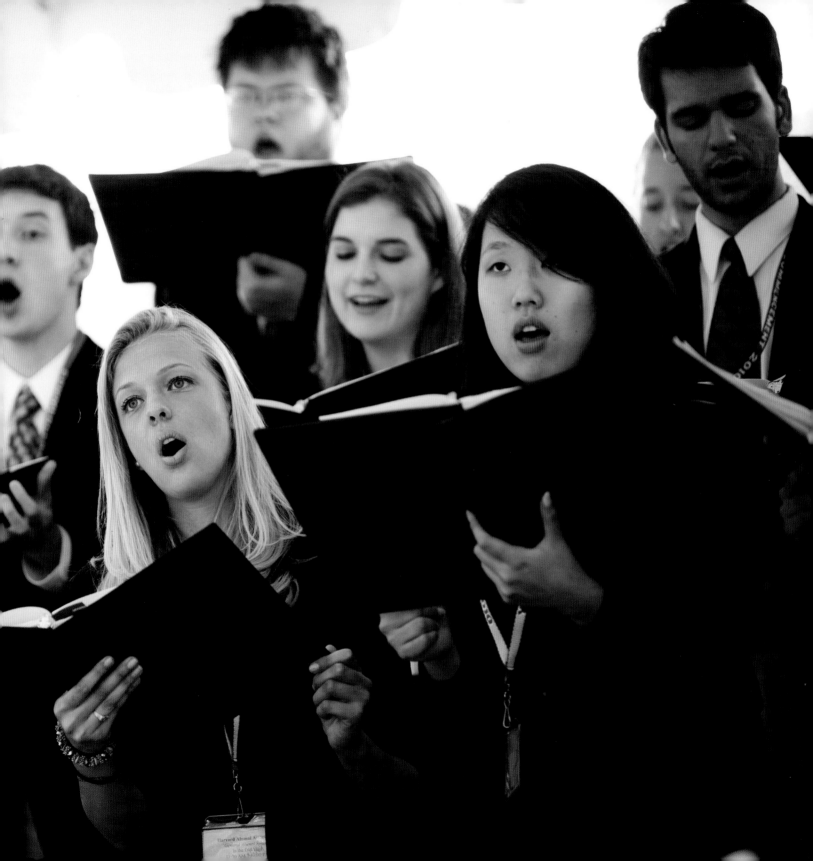

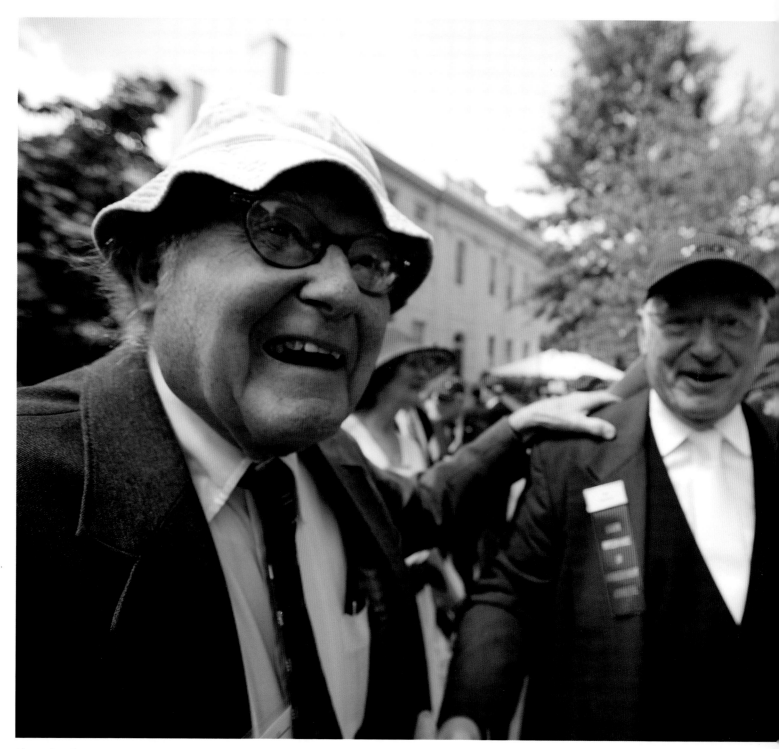

Alumni Parade, 2010

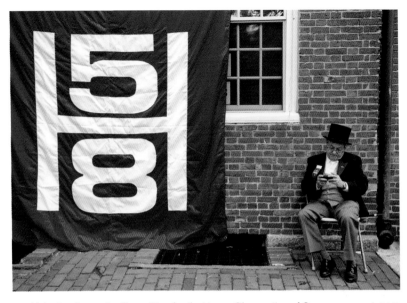

Volunteering on the Committee for the Happy Observation of Commencement, 2010

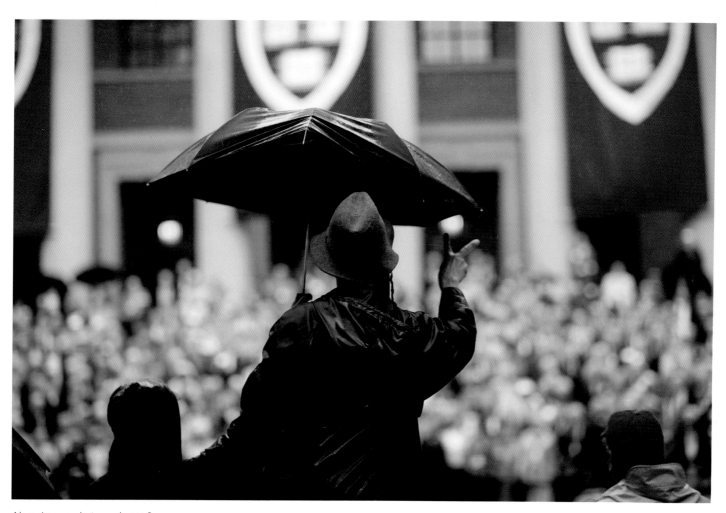

Alumni group photograph, 2008

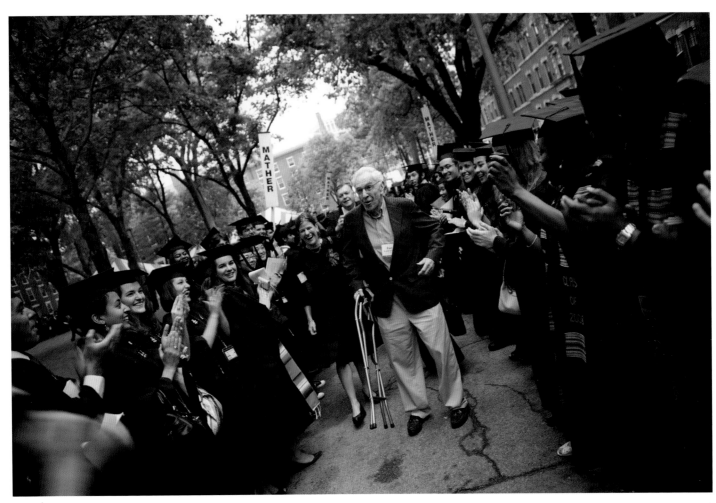

Alumni process into Tercentenary Theatre, 2008

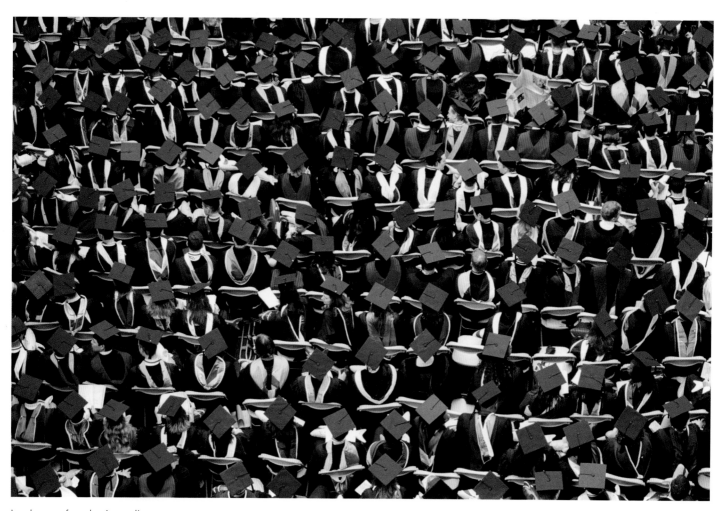

Landscape of academic regalia, 2003

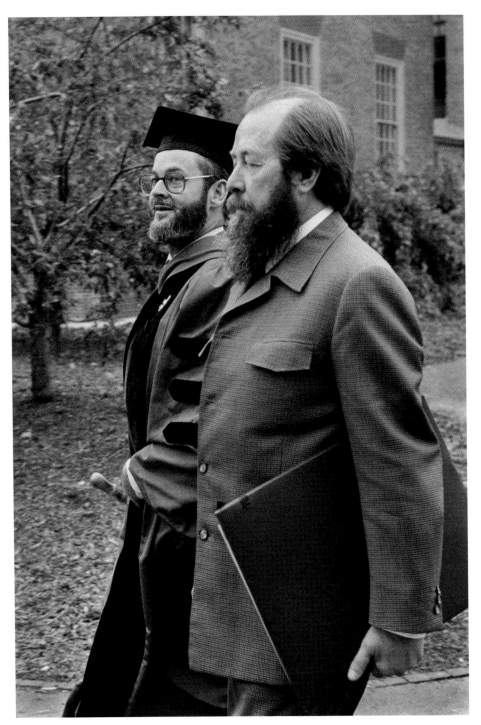

Alexander Solzhenitsyn at Class Day, 1978

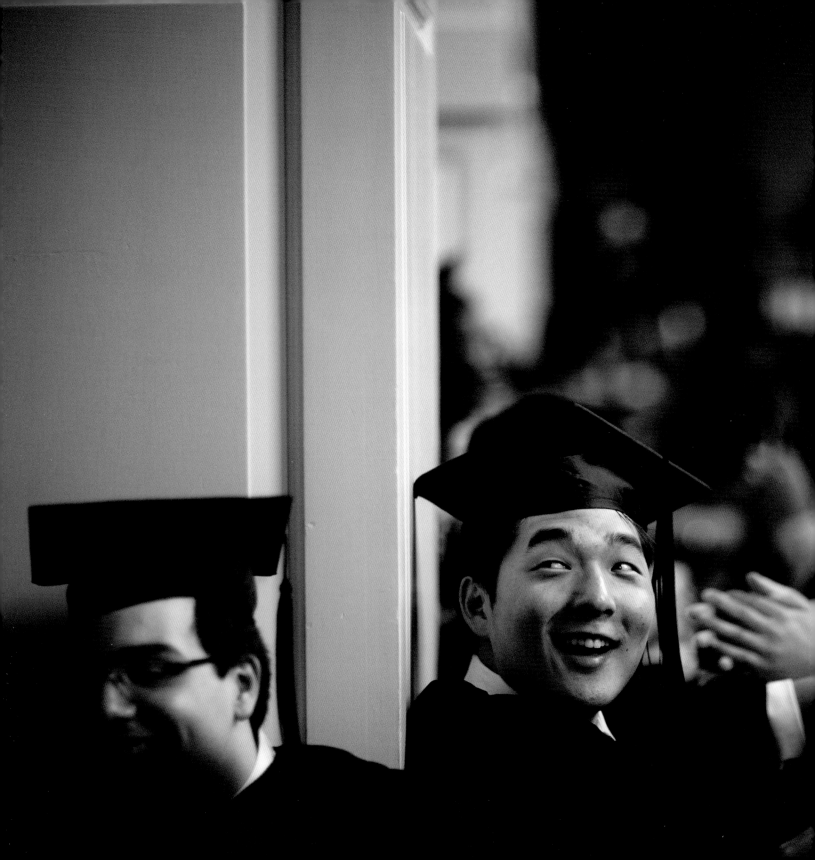

249

Chapel service in Memorial Church, 2008

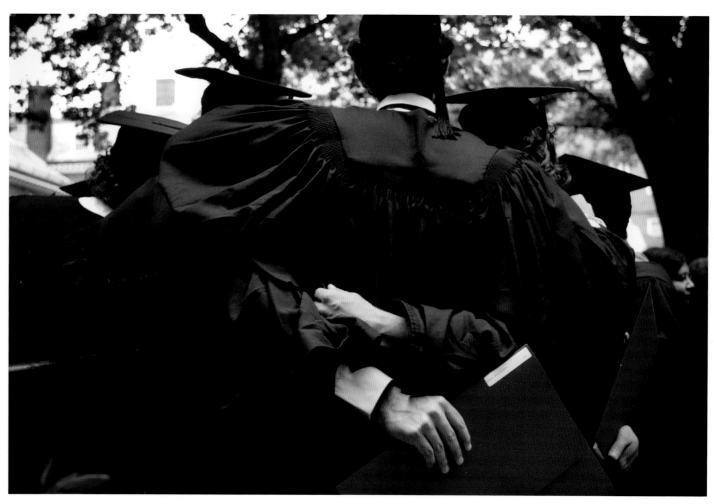

Kirkland House degree presentation, 2008

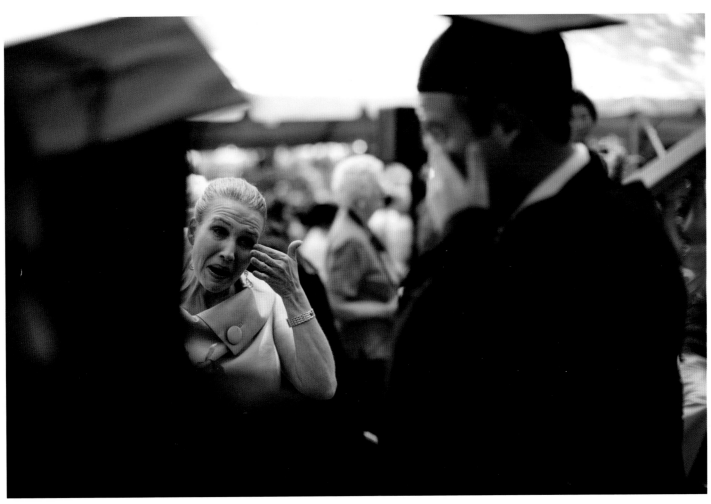

Winthrop House degree presentation, 2010

Projecting Crimson, 2009

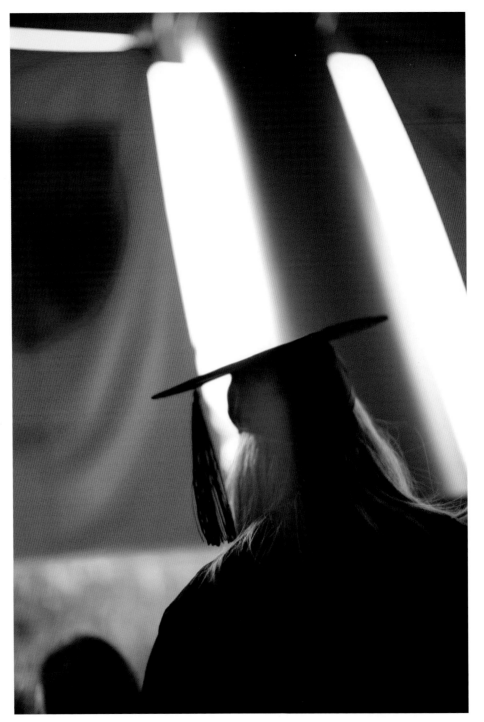

The future beckons, 2010

PHOTOGRAPHY CREDITS

Page 6, Stephanie Mitchell

Pages 8–9, Kris Snibbe

Page 10, Stephanie Mitchell

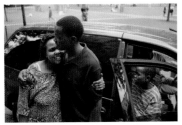

Page 11, Kris Snibbe

Page 12, Jon Chase

Page 13, Christopher S. Johnson, The Schlesinger Library, Radcliffe Institute, Harvard University

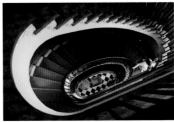

Pages 14–15, Kris Snibbe

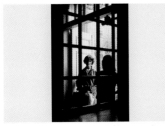

Page 16, Edwin G. Snyder, The Schlesinger Library, Radcliffe Institute, Harvard University

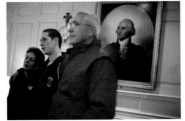

Page 17, Stephanie Mitchell

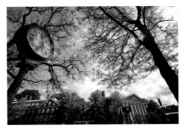

Pages 18–19, Stephanie Mitchell

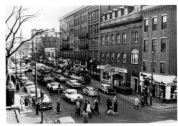

Page 20, Harvard University Archives, HUV 80 (10-10)

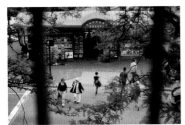

Page 21, Rose Lincoln

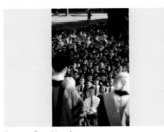

Page 22, Rose Lincoln

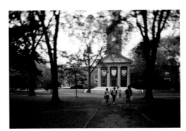

Page 23, Justin Ide

Page 24, Kris Snibbe

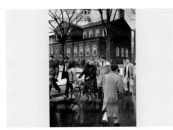

Page 25, John Loengard, Harvard University Archives, HUPSF Student Life (203)

Page 26, Kris Snibbe

Page 27, Stephanie Mitchell

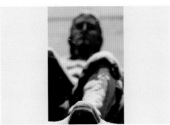

Page 30, Jon Chase

Pages 32–33, Rose Lincoln

Page 34, Stephanie Mitchell

Page 35, Justin Ide

Page 36, Stephanie Mitchell

Page 37, Rose Lincoln

Page 38, H. B. Albright, Harvard University Archives, HUV 20 (12-1)

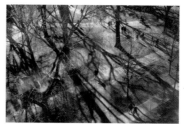

Page 39, Kris Snibbe

Pages 40–41, Kris Snibbe

Page 42, Stephanie Mitchell

Page 43, Justin Ide

Page 44, Kris Snibbe

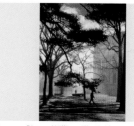

Page 45, Rittase William, The Schlesinger Library, Radcliffe Institute, Harvard University

Page 46, Kris Snibbe

Page 47, Justin Ide

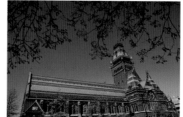

Pages 48–49, Stephanie Mitchell

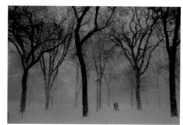

Page 50, Kris Snibbe

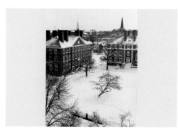

Page 51, David L. Crofoot, The Schlesinger Library, Radcliffe Institute, Harvard University

Page 52, Stephanie Mitchell

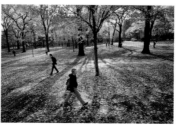

Page 53, Kris Snibbe

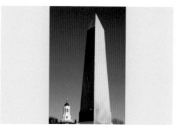

Page 54, Matt Craig

Page 55, Stephanie Mitchell

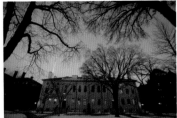

Page 56, Kris Snibbe

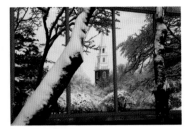

Page 57, Jon Chase

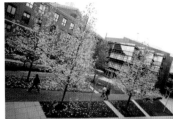

Page 58, Stephanie Mitchell

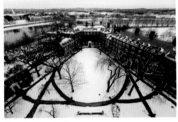

Page 59, Matt Craig

Page 62, Justin Ide

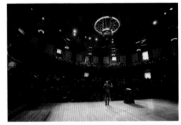

Pages 64–65, Justin Ide

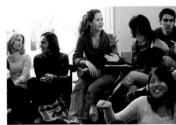

Page 66, Stephanie Mitchell

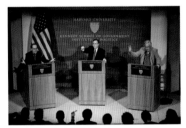

Page 67, Stephanie Mitchell

Page 68, Justin Ide

Page 69, Rose Lincoln

Page 70, Rose Lincoln

Page 71, John Brook, Harvard University Archives, HUV 49 (10-10)

Page 72, Justin Ide

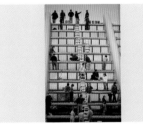

Page 73, Justin Ide

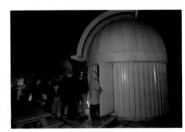

Page 74, Jon Chase

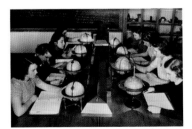

Page 75, The Schlesinger Library, Radcliffe Institute, Harvard University

Page 76, Emily Berl

Page 77, Stephanie Mitchell

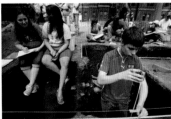

Pages 78–79, Stephanie Mitchell

Page 80, Stephanie Mitchell

Page 81, Harvard University Archives, UAV 605, Box 11

Page 82, Stephanie Mitchell

Page 83, Rose Lincoln

Page 84, Kris Snibbe

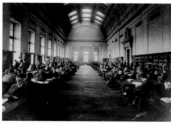

Page 85, Notman, Harvard University Archives, HUV 49 (15-6)

Page 86, Stephanie Mitchell

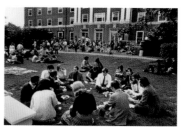

Page 87, Lynn Millar, The Schlesinger Library, Radcliffe Institute, Harvard University

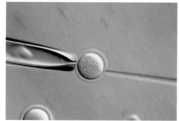

Page 88, Justin Ide

Page 89, Harvard University Archives, HUV 20 (19-11b)

Page 92, Justin Ide

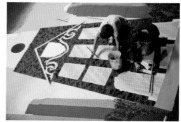

Pages 94–95, Stephanie Mitchell

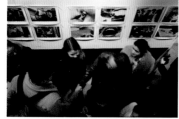

Page 96, Stephanie Mitchell

Page 97, Kris Snibbe

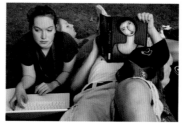

Page 98, Kris Snibbe

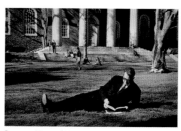

Page 99, Harvard University Archives, HUPSF Nieman Fellows (31)

Page 100, Stephanie Mitchell

Page 101, Kris Snibbe

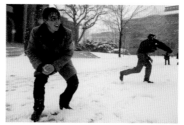

Pages 102–103, Kris Snibbe

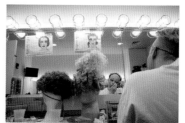

Page 104, Stephanie Mitchell

Page 105, Harvard University Archives, HUPSF Hasty Pudding Club (24)

Page 106, Press Association, Inc., Harvard University Archives, HUPSF Student Life (55)

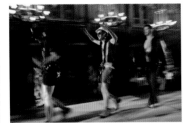

Page 107, Kris Snibbe

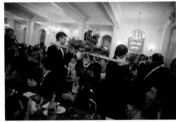

Page 108, Justin Ide

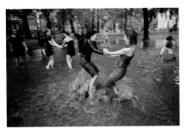

Page 109, Kris Snibbe

Page 110, Kris Snibbe

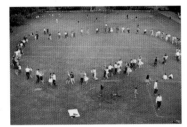

Page 111, Kenneth C. Hird, The Schlesinger Library, Radcliffe Institute, Harvard University

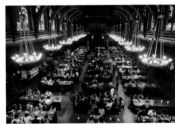

Pages 112–113, Justin Ide

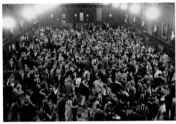

Page 114, Harvard University Archives, HUV 166 (18-5)

Page 115, Stephanie Mitchell

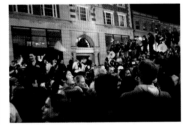

Page 116, Stephanie Mitchell

Page 117, Stephanie Mitchell

Page 120, Kris Snibbe

Pages 122–123, Justin Ide

Page 124, The Schlesinger Library, Radcliffe Institute, Harvard University

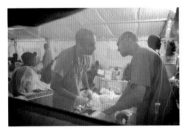

Page 125, Justin Ide

Page 126, Rose Lincoln

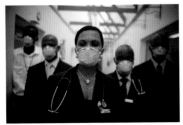

Page 127, Justin Ide

Pages 128–129, Justin Ide

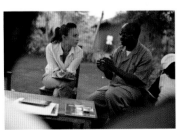

Page 130, Justin Ide

Page 131, Stephanie Mitchell

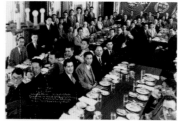

Pages 132–133, Statler, Harvard University Archives, HUD 3277.3000 (PA 1)

Page 134, Kris Snibbe

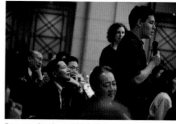

Page 135, Stephanie Mitchell

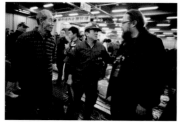

Pages 136–137, Stephanie Mitchell

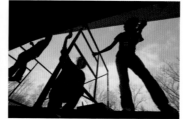

Page 138, Kris Snibbe

Page 139, Kris Snibbe

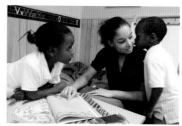

Page 140, Kris Snibbe

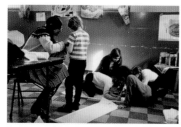

Page 141, Ivar Viehe-Naess, The Schlesinger Library, Radcliffe Institute, Harvard University

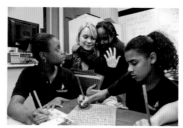

Page 142, Jon Chase

Page 143, Rose Lincoln

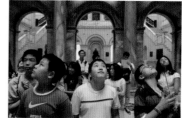

Page 144, Kris Snibbe

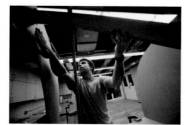

Page 145, Stephanie Mitchell

Pages 146–147, Stephanie Mitchell

Page 148, Stephanie Mitchell

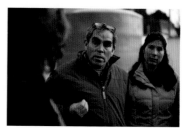

Page 149, Stephanie Mitchell

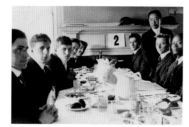

Page 150, Harvard University Archives, HUD 3404 (photo 1)

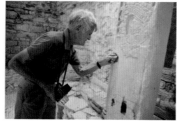

Page 151, Justin Ide

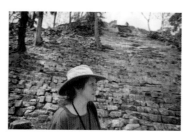

Page 152, Justin Ide

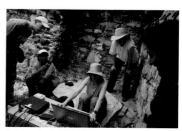

Page 153, Justin Ide

Pages 154–155, Justin Ide

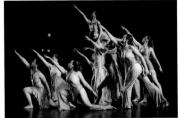
Page 158, Matt Craig

Pages 160–161, Kris Snibbe

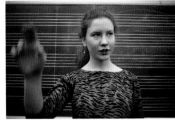
Page 162, Justin Ide

Page 163, Rick Bertocci, The Schlesinger Library, Radcliffe Institute, Harvard University

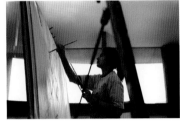
Page 164, Rose Lincoln

Page 165, Katherine C. Cohen

Page 166, Stephanie Mitchell

Page 167, Stephanie Mitchell

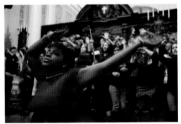
Page 168, Kris Snibbe

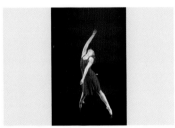
Page 169, Stephanie Mitchell

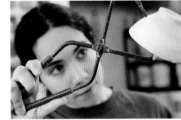
Page 170, Jon Chase

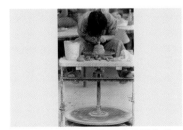
Page 171, The Schlesinger Library, Radcliffe Institute, Harvard University

Page 172, Rose Lincoln

Page 173, Stephanie Mitchell

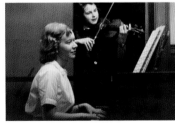
Page 174, The Schlesinger Library, Radcliffe Institute, Harvard University

Page 175, Stephanie Mitchell

Page 176, Rose Lincoln

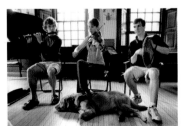
Page 177, Rose Lincoln

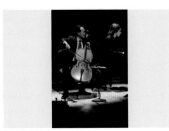
Page 178, Nick Welles

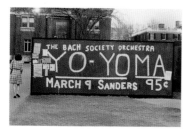

Page 179, E. B. Boatner, The Schlesinger Library, Radcliffe Institute, Harvard University

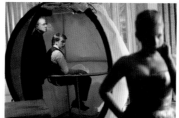

Pages 180–181, Kris Snibbe

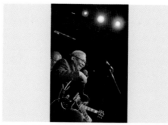

Page 182, Rose Lincoln

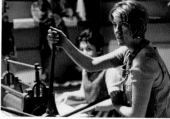

Page 183, Olive Pierce, The Schlesinger Library, Radcliffe Institute, Harvard University

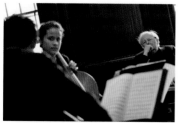

Page 184, Stephanie Mitchell

Page 185, Harvard University Archives, UAV 605.270.1.2 (U-672)

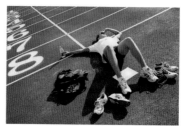

Page 188, Kris Snibbe

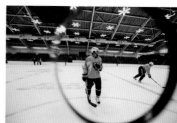

Pages 190–191, Rose Lincoln

Page 192, Matt Craig

Page 193, Harvard University Archives, HUPSF Hockey (4)

Page 194, Rose Lincoln

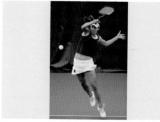

Page 195, Jon Chase

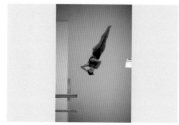

Page 196, Justin Ide

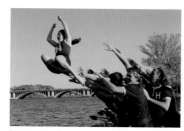

Page 197, Jon Chase

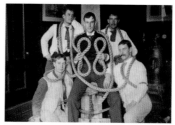

Page 198, Harvard University Archives, HUPSF Tug of War (2)

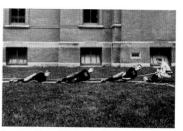

Page 199, Harvard University Archives, HUPSF Tug of War (5)

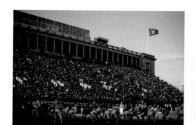

Pages 200–201, Justin Ide

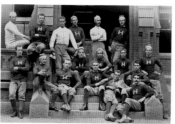

Page 202, Harvard University Archives, HUP-SF Football (5)

Page 203, Justin Ide

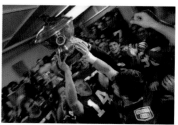

Page 204, Justin Ide

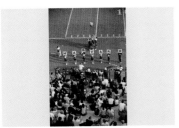

Page 205, Rose Lincoln

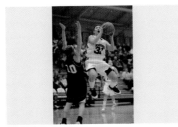

Page 206, Jon Chase

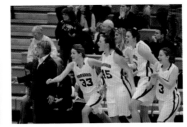

Page 207, Katherine C. Cohen

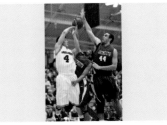

Page 208, Jon Chase

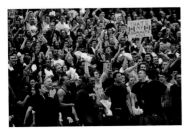

Page 209, Jon Chase

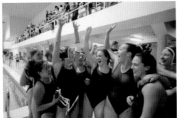

Page 210, Kris Snibbe

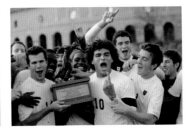

Page 211, Jon Chase

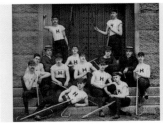

Page 212, Harvard University Archives, HUPSF Lacrosse (2a)

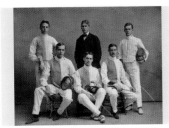

Page 213, Harvard University Archives, HUPSF Fencing (7)

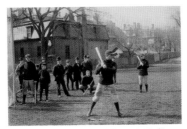

Page 214, Pach Bros., Harvard University Archives, HUPSF Baseball (46)

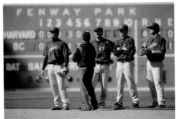

Page 215, Jon Chase

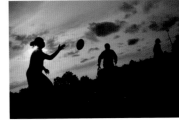

Page 216, Rose Lincoln

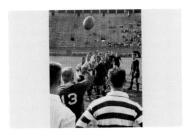

Page 217, Harvard University Archives, HUPSF Rugby (6)

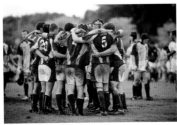

Pages 218–219, Justin Ide

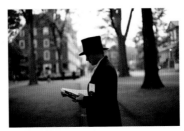

Page 222, Stephanie Mitchell

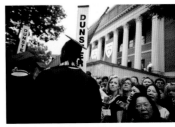

Pages 224–225, Stephanie Mitchell

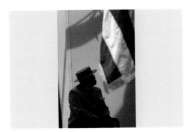

Page 226, Kris Snibbe

Page 227, Kris Snibbe

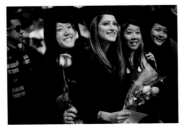

Page 228, Stephanie Mitchell

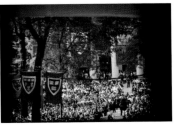

Page 229, Stephanie Mitchell

Pages 230–231, Rose Lincoln

Pages 232–233, Rose Lincoln

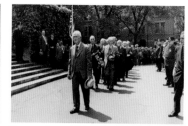

Page 234, Harvard University Archives, HUPSF Commencement 1947 (1)

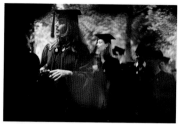

Page 235, Rose Lincoln

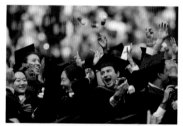

Page 236, Jon Chase

Page 237, Stephanie Mitchell

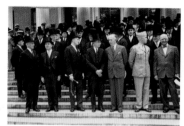

Page 238, Harvard University Archives, HUPSF Commencement 1947 (10)

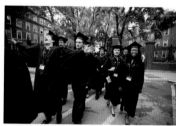

Page 239, Rose Lincoln

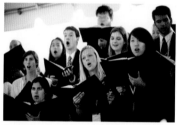

Pages 240–241, Stephanie Mitchell

Page 242, Rose Lincoln

Page 243, Kristyn Ulanday

Page 244, Matt Craig

Page 245, Matt Craig

Page 246, Kris Snibbe

Page 247, Harvard University Archives, HUPSF Commencement 1978 (14)

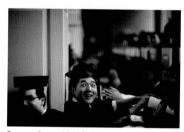

Pages 248–249, Matt Craig

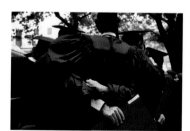

Page 250, Stephanie Mitchell

Page 251, Stephanie Mitchell

Page 252, Kris Snibbe

Page 253, Stephanie Mitchell

ACKNOWLEDGMENTS

Many books are the products of collaboration, but this book may be more so than most. At its core, it reflects years of patient lens work by the staff photographers of the Harvard Public Affairs & Communications office and the careful eye of Stephanie Mitchell, who culled through our archive to select photographs that show the full breadth of the Harvard experience, and then found the poetry to accent the images. Kevin Galvin crafted the prose that introduces each section. We are indebted to Seamus Heaney for taking the time to write such a generous introduction. Christine Heenan oversaw the project with help from Jennifer Anderson, Amy Rollins, John Longbrake, and Perry Hewitt. Thanks to the staff of the Harvard University Press, especially Susan Wallace Boehmer and Tim Jones, whose expertise proved indispensable. Harvard is a remarkable place. We hope that this collaboration has opened a window that will allow more people to see it for themselves.